MONET

IN THE TIME OF THE WATER LILIES

THE MUSÉE MARMOTTAN MONET COLLECTIONS

Marianne Delafond and Caroline Genet-Bondeville

Musée
Marmottan
M●net

EDITIONS SCALA

The authors would like to express
their special thanks to
Monsieur Arnaud d'Hauterives,
the Permanent Secretary
of the Académie des Beaux-Arts,
who instigated this book.

Éditions Scala
Passage Lhomme
26 rue de Charonne
75011 Paris

Graphic design:
★Bronx (Paris)

Cover design:
Jean-Pierre Jauneau

Layout:
Tauros

Translation:
Judith Hayward

Diffusion - Distribution:
CDE - Sodis

Captions where the artist's name
is not indicated refer to works by Monet.

Contents

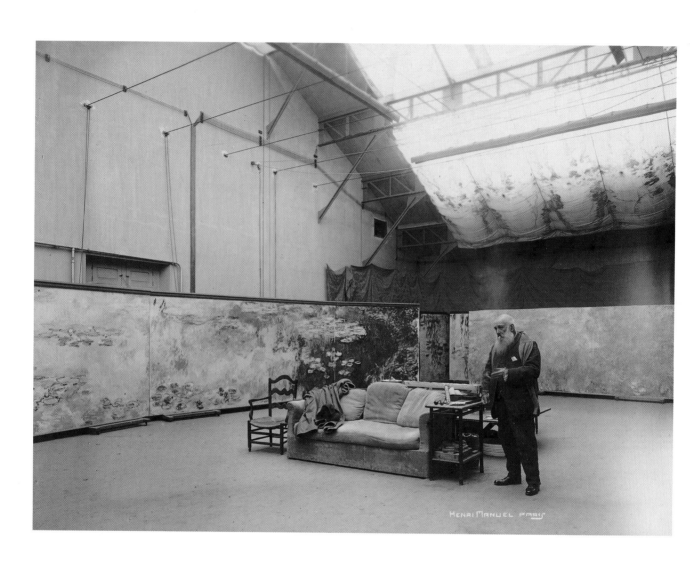

Foreword

Jean-Marie Granier
Director of the Marmottan Foundation

The Musée Marmottan Monet has benefited over the years from exceptional gifts and bequests, which mean that it is a centre of attraction for Impressionist painting; and the work of Claude Monet with several hundred pictures is particularly well placed, surrounded as it is by that of his friends and fellow artists and those who preceded, accompanied or followed them.

The presentation of this collection in the mansion bequeathed to the Académie des Beaux-Arts by Paul Marmottan in 1932 has been carefully and skilfully undertaken by the museum's successive curators and directors, Jacques Carlu, Yves Brayer and Arnaud d'Hauterives, who have successfully recreated a sense of the atmosphere in which Monet designed the garden at Giverny, which he used as model for his paintings, at the same time as painting pictures of it in a balanced fusion of the elements of a world in perpetual transformation.

The work carried out in producing this book by Madame Delafond, the curator, and Madame Genet-Bondeville the deputy curator, of course pays tribute to the works held by the musée Marmottan Monet, but also to the people who through their gifts and efforts made the whole thing possible.

Our thanks are due to the authors.

<
Monet in his studio at Giverny
c. 1923
Photograph
MMM Archives

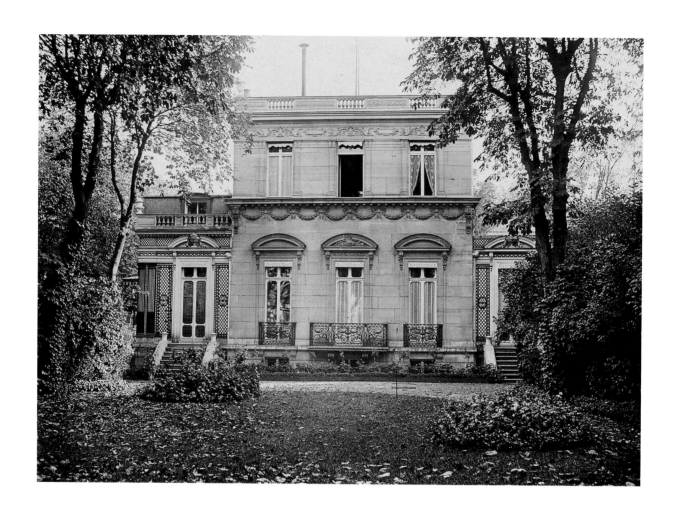

How the museum came into being

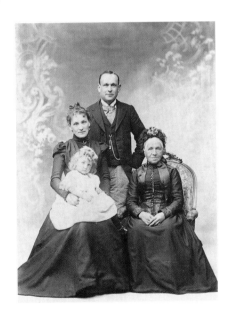

"**I appoint as universal legatee in total ownership the Musée Marmottan in Paris. Made at Sorel, on 4 March 1964. Michel Monet.**" In bequeathing all the pictures he had inherited from his father and the property at Giverny to the Musée Marmottan, a foundation that comes under the Académie des Beaux-Arts, the painter's second son endowed it with the largest collection of works by Claude Monet in the world.

In order to present it, space had to be found in the mansion which Paul Marmottan had bequeathed to the Academy thirty years earlier. Marmottan, a historian and collector, had turned the former hunting lodge of the Duc de Valmy into a comfortable residence where he could exhibit the paintings, furniture and bronzes from the Napoleonic era which he had purchased in Paris or in the course of his many travels.

It was in 1966 that the architect Jacques Carlu, then the museum's curator, created a huge, elegant room under part of the garden, conforming to the latest museological standards.

The formal opening took place on 8 June 1971. "A dazzling reparation accorded by the Académie des Beaux-Arts to those it fought for so long! All the 120 works bequeathed by Michel Monet join the Donop de Monchy bequest. All the great names of Impressionism are side by side here as they were at Giverny, grouped round the man a painting by whom – present here – gave Impressionism its name. All periods of Monet are represented, from *Personnages sur la plage* (Figures on the beach), 1870, to the final magical sketches inspired by the flower-filled ponds and gardens at Giverny."[1] Victorine Donop de Monchy had already

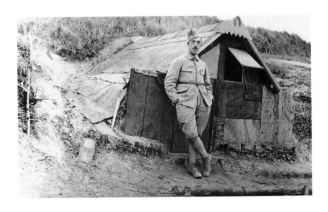

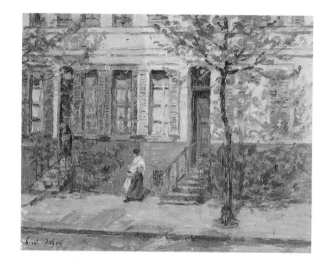

∧ ∧
View of the Monet room
Photograph
MMM Archives

∧
Henri Duhem
(1860-1941)
Scène de rue
(Street scene)
1912

Oil on wood
19 × 22 cm
Nelly Sergeant-Duhem Donation, 1985
Inv. 5317

given the Musée Marmottan the collection she had inherited from her father, Georges de Bellio, in 1957. A homeopathic doctor of Rumanian origin, he had attended Manet, Monet, Pissarro, Sisley and Renoir. He had bought his first picture by Monet in 1874, a date memorable for the first Impressionist exhibition. His admirable collection included the famous *Impression, Soleil levant* (Impression, Sunrise).

This extraordinary group of works has been supplemented thanks to the generosity of Nelly Duhem, the adopted daughter of Mary Sergeant and the painter Henri Duhem. A comrade-in-arms of the post-Impressionists, Duhem was also a keen buyer of the paintings, pastels and drawings of Boudin, Carrière, Corot, Gauguin, Guillaumin, Monet, Renoir, Lebourg and Le Sidaner.

Thus, ever since the Musée Marmottan Monet was created in 1934, it has not ceased to be further enriched by exceptional donations, among them the collection of illuminations made by Georges Wildenstein, bequeathed by his son Daniel. More recently the Denis and Annie Rouart Foundation, named after Berthe Morisot's grandson, has donated masterpieces, oil paintings and drawings by Morisot, Manet, Degas, Renoir and Rouart to the museum.

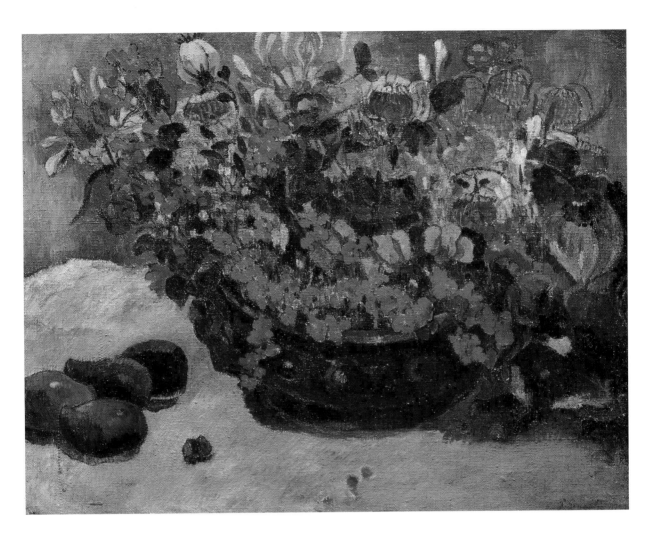

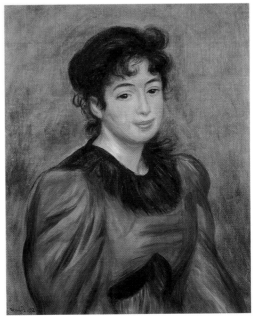

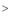

∧
Paul Gauguin
(1848-1903)
Bouquet de fleurs
(Bunch of flowers)
1897

Oil on canvas
73 × 93 cm
Nelly Sergeant-Duhem Donation, 1985
Inv. 5333

>

Auguste Renoir
(1841-1919)
Portrait de Melle Victorine de Bellio
(Portrait of Mademoiselle Victorine de Bellio)
1892

Oil on canvas
55 × 46 cm
Victorine Donop de Monchy Bequest, 1957
Inv. 4024

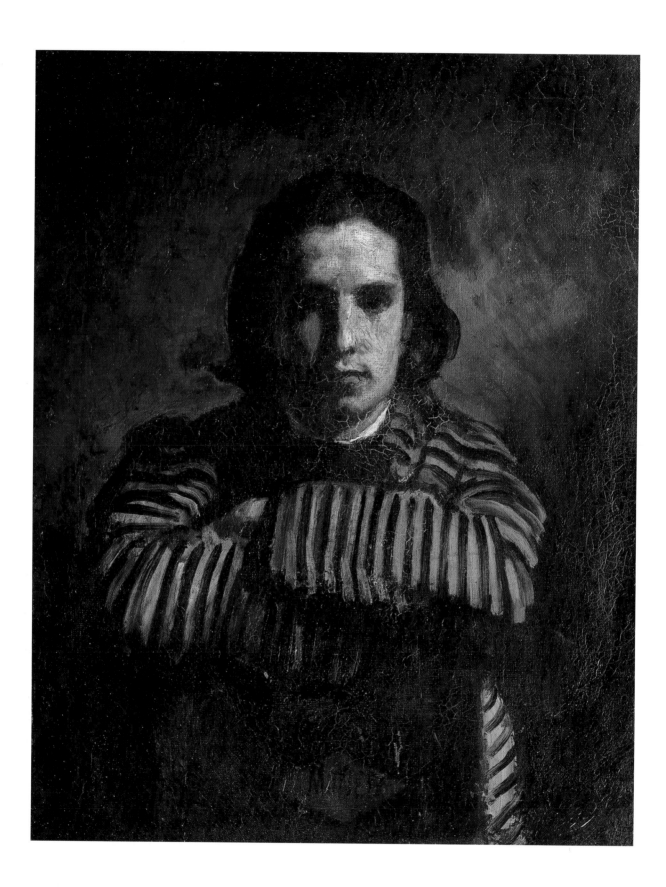

The arrogance of youth

From his first artistic discoveries at the seaside to the height of the sarcastic attacks by popular opinion on the group of young intransigents who had the audacity to exhibit their work, Monet with his "ambitious brush" pursued his untiring quest "for heightened truth in interpretations of nature."

<
Gilbert Alexandre Séverac
(1834-1897)
Portrait de Claude Monet
(Portrait of Claude Monet)
1865

Oil on canvas
40 × 32 cm
Michel Monet Bequest, 1966
Inv. 5065

∧
Benque
Claude Monet
c. 1879

Photograph

"I'm a true Parisian. I was born in Paris, in 1840, (..) into a background totally dedicated to business where they displayed a contemptuous disdain for the arts,"[1] **Claude Monet confided to Thiébault-Sisson. But it was in Normandy that his vocation as a painter was born.** After several financial disappointments, his father Adolphe Monet in fact decided to leave the capital in 1845. He joined his half-sister, Marie-Jeanne Lecadre, at Le Havre; her husband had a chandler's business which supplied ships leaving the port. Oscar Claude Monet was five years old when, in the company of his elder brother Léon, he got to know this cosmopolitan trading city looking out over the ocean. He stayed there until he left for Paris in 1859.

Of his youth, we know only the few memories he gave of it late in life. He told of the united family living in a happy atmosphere, destroyed in 1857 by the death of his mother. His aunt then took care of him, and the following year encouraged his desire to paint. "Unruly from birth,"[2] Monet compared secondary school to a prison. He escaped from it in his own fashion through drawing, sketching "in the most irreverent way, deforming them as much as possible, the full faces or profiles of (his) schoolmasters".[3] While he received the strict teaching of Ochard, a former pupil of David, at school, he also made copies that he kept throughout his life of unkind character sketches by the famous graphic artist and photographer, Félix Nadar, published in the *Journal Amusant*

>

*Jeune homme au monocle
(Young man with a monocle)*
1857

Pencil on beige paper heightened
with gouache
24 × 16
André Billecocq Donation, 1982
Inv. 5221

> >

*Dandy au cigare
(Dandy with a cigar)*
1857

Heightened drawing
24 × 16 cm
André Billecocq Donation, 1982
Inv. 5227

> > >

*Femme noire coiffée d'un madras
(Black woman wearing
a madras head-dress)*
1857

Pencil heightened with gouache
24 × 16 cm
André Billecocq Donation, 1982
Inv. 5223

∨

*Petit panthéon théâtral
(Little theatrical pantheon)*
1860

Pencil heightened with gouache
Michel Monet Bequest, 1966
Inv. 5161

or the *Panthéon*. The first drawings which he signed *Oscar,* apart from a few landscapes, are small character portraits of Le Havre notabilities, caricatures which he offered for sale at the shop of the framer and art materials supplier Gravier, so succeeding in building up a little nest egg for himself. It was at Gravier's that he made the acquaintance of his first mentor.

"It was like a veil being torn"

Eugène Boudin was intrigued by the young caricaturist's drawings in the shop window, and wanted to meet him. But Oscar jibbed at meeting the man who showed his "little works" in the same window, and attracted the mockery of those who looked in. The year was 1858, Boudin was thirty-four years old, Monet eighteen. He eventually persuaded the young man to come and paint with him in the open air. Within a few months he would "undertake his education", with no grand doctrines, but with the sincerity of someone devoting his life to what he loved, nature and art, convinced that "perfection is a collective process; had it not been for this thing, that one would never have achieved the perfection it has".[4] Monet described these times spent with Boudin as amazing. "It was like a veil being torn: I had understood, I had grasped what painting could be [...] If I have become a painter, it is to Boudin that I owe it."[5] (...) "Oh, what a revelation! ...The light had just burst forth."[6] Despite the refusal of the Le Havre municipal authorities to grant him a bursary, on Boudin's advice Monet went

<
Eugène Boudin
(1824-1898)
*Crinolines sur la plage
(Crinolines on the beach)*

Watercolour
17 × 27 cm
Michel Monet Bequest, 1966
Inv. 5057

∨
Eugène Delacroix
(1798-1863)
*Falaises près de Dieppe
(Cliffs near Dieppe)*
1852

Watercolour
20 × 31 cm
Michel Monet Bequest, 1966
Inv. 5052

∨ ∨
Eugène Delacroix
(1798-1863)
*Falaises d'Étretat. Le Pied de Cheval
(Cliffs at Étretat. The Pied de Cheval)*
1838

Watercolour and gouache
15 × 20 cm
Michel Monet Bequest, 1966
Inv. 5053

to the capital to complete his artistic education. Very soon convinced of the importance of not becoming isolated, he awaited his elder colleague impatiently in "this amazing Paris". He sent him impressions of his visits to the Salon: "They are only suggestions, sketches; but as always he has verve, movement," he said of the paintings of Eugène Delacroix. "(...) The Corots are pure marvels."[7] Through a recommendation from his first master, Monet met Constant Troyon, a famous Barbizon painter: "I showed him two of my still-lifes (...). He said to me: 'Well, young man, you'll have colour; the effect is right; (...) but draw powerfully (...) If you want my advice: if I was starting my career again, I'd go to Couture'."[8] But he chose instead to go to the Académie Suisse, an "independent" studio where a painter could work without being impeded by dogma. "Trusting in the unfailing honesty of his vision," Clemenceau sums up, "he stuck obstinately and fiercely to painting what he saw as he saw it."[9] The same studio counted Pissarro, Guillaumin and Gauguin among its pupils.

However, as he was facing an ever more precarious financial situation and soon had to do his military service, Monet anticipated his conscription and enrolled as a volunteer in 1861. He chose the Chasseurs d'Afrique – a light cavalry regiment serving in North Africa. Following a bout of typhoid fever, he returned from Algeria in June of the same year, when he made the acquaintance of Johann Barthold Jongkind who was

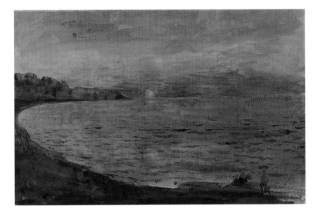

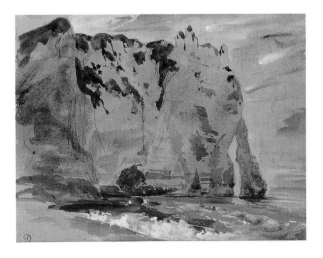

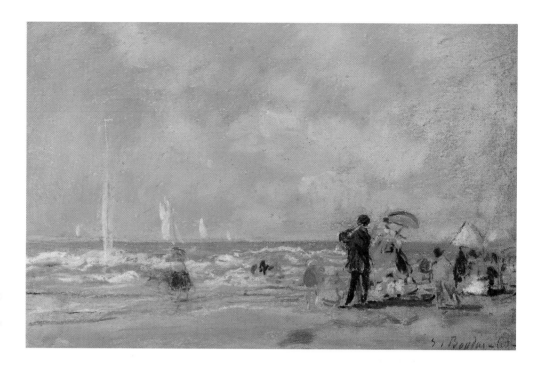

>
Eugène Boudin
(1824-1898)
*Sur la plage
(On the beach)*
1863

Watercolour and pastel
19 x30 cm
Michel Monet Bequest,
1966
Inv. 5035

V
Eugène Boudin
(1824-1898)
*Voilier à marée basse
(Sailing ship at low tide)*
c. 1883

Oil on canvas
27 x22 cm
Nelly Sergeant-Duhem Donation,
1985
Inv. 5299

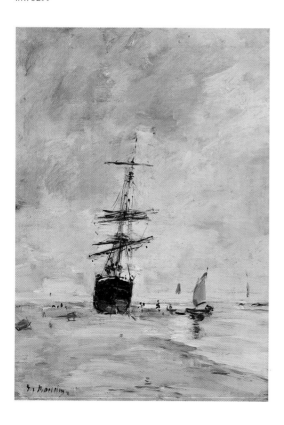

staying in Honfleur that summer with his female companion, Madame Fesser. At the height of his mastery of his art, the Dutch painter reconstituted nature in its essential lines, and in his diaphanous water colours displayed an immense freedom which Monet described as the "accurate unexpected".[10]

Monet introduced the man whose work would remain for him "at the origin with Corot of what is called Impressionism"[11] to Boudin. Very quickly their elective affinities made them inseparable, and Monet wrote to Bazille who had stayed in Paris: "Jongkind and Boudin are here, we get on like a house on fire and are never out of one another's company."[12] Life did separate them, however, but Boudin remained in contact with the younger man by letter and followed his progress with special affection. In a letter he sent to Monet on Jongkind's death, the "king of the skies" spoke very nostalgically of their outings in Normandy: "For many years the vagaries of existence and the necessities of life have doubtless kept us apart, but I have nonetheless taken part in your efforts, in your successes (...) I have followed you with interest in your bold ventures, daring ventures even, but ones that have brought you fame and renown. It's a long, long time since we used to go and try our hands at landscape (...) with that good, great, much mourned Jongkind."[13]

Monet had not forgotten. Out of admiration for Jongkind's work and in memory of him, at the sale of his studio in December 1891 he bought *Une rue d'Avignon* (A street in Avignon) and a watercolour, *Port-Vendres*.

"The future will name Jongkind between Corot and M. Claude Monet as the connecting link between two periods,"[14] the journalist Louis de Fourcaud of the *Gazette des Beaux-Arts* predicted in his preface to the catalogue. In 1862 the painter Auguste Toulmouche, given the task of overseeing the artistic studies of his cousin Oscar Claude Monet, advised him to join the famous studio of the Vaudois history painter, Charles Gleyre. At that school which ran for over twenty-five years and witnessed the passage of many artists including Gérome and Whistler, Monet made the acquaintance of Renoir, Bazille and Sisley. The fellow students had very little to learn from this master who regarded landscape as a "decadent art" and whose ideas ran counter to their aspirations.

Preferring the present to the past, they made a rapid escape. "Monsieur Gleyre is quite ill, it seems the poor man is in danger of losing his sight," Bazille who came from Montpellier wrote to his parents. The friends went off and took up residence at the Auberge du Cheval Blanc in the little village of Chailly-en-Bière, and went out to paint from nature in the forest of Fontainebleau.

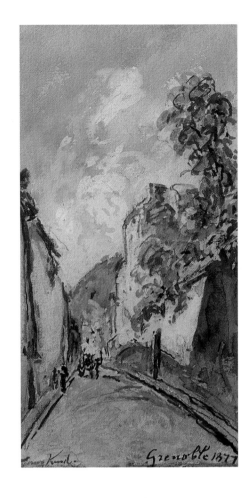

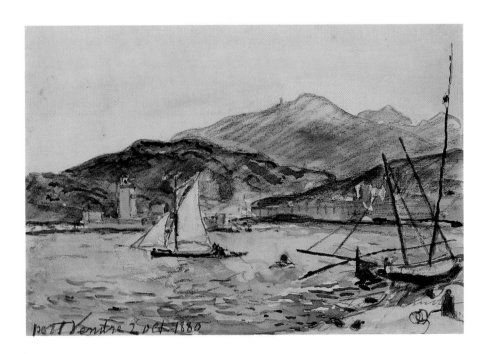

∧
Johan Barthold Jongkind
(1819-1891)
Rue de Grenoble
(Street in Grenoble)
1877

Watercolour
21 × 11 cm
Nelly Sergeant-Duhem Donation,
1985
Inv. 5324

<
Johan Barthold Jongkind
(1819-1891)
Port-Vendres
1880

Watercolour
17 × 24 cm
Michel Monet Bequest, 1966
Inv. 5004

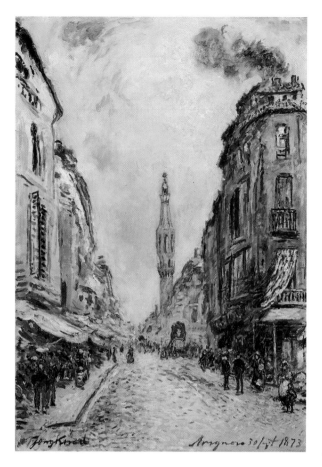

The three-man escapade was short-lived. In Paris they found people who shared their aspirations, and with Manet, who was older than them, formed the Batignolles group. Fourteen years later, they were to create a company of independent artists in order to show their works, in spite of official rebuffs.

"A young battalion that will make its mark"[15]

In 1867 Édouard Manet, who "anticipated nothing good"[16] from the Salon jury, decided "to hold a private exhibition"[17] and "go the whole hog"[18], following the example of Gustave Courbet who that same year repeated his 1855 challenge at the Rond-Point de l'Alma. Bazille, Monet, Renoir and their fellow pupils who had met at Charles Gleyre's had likewise already come up against the despotism of the jury members. "We want to rent a large studio every year where we will exhibit as many of our works as we wish," Bazille wrote. "We will invite painters we like to send in pictures (…). With those people and Monet, who is stronger than any of them, we are sure to succeed (…)."[19] But a lack of funds initially forced the group to give up the idea of following the example of the Ornans master in his emancipation from the academic authorities. It was only after the Franco-Prussian war of 1870 that this plan finally came to fruition, unfortunately without Bazille who had tragically been killed at the Battle of Beaune-la-Rolande. In 1874 Monet, Renoir, Pissarro, Sisley, Degas, Cézanne, Guillaumin and Berthe Morisot in their turn challenged the Salon by organizing their own exhibition. Even if their ideas differed at times, they fought together against "those old one-eyed idiots"[20] embodying conservatism, the critics and the gibes of the public. Bonded together through necessity, the group survived until the 1886 exhibition despite defections and rivalries.

Immediately the exhibition opened at the former studio of the photographer Nadar at 25 Boulevard des Capucines, the curious public turned up in large numbers, hoping to be entertained. That first show created quite a stir. But the good will of some people was offset by a traditionalist press, and the ridicule or surly attitude of some critics who regarded themselves as called upon to defend moral order. Monet submitted

Λ
Johan Barthold Jongkind
(1819-1891)
*Une rue d'Avignon
(A street in Avignon)*
1873
Oil on canvas
46 × 33 cm
Michel Monet Bequest, 1966
Inv. 5015

>
Édouard Manet
(1832-1883)
*Portrait de Berthe Morisot
étendue
(Portrait of Berthe Morisot,
reclining)*
1873
Oil on canvas
26 × 34 cm
Denis and Annie Rouart Foundation,
1996
Inv. 6086

>
Édouard Manet
Photograph
Archives MMM

The arrogance of youth *17*

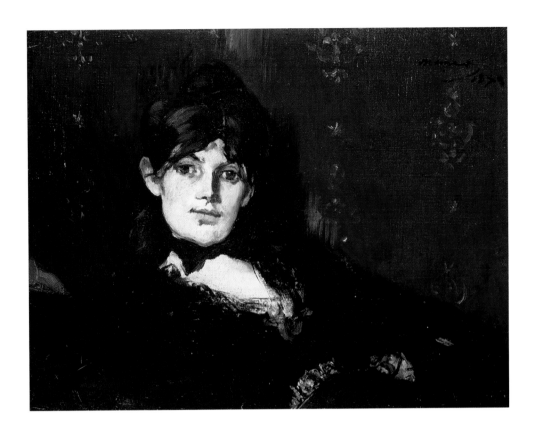

five pictures including "Something painted at Le Havre
(...) They asked me for the title for the catalogue, it
couldn't really pass as a view of Le Havre. I answered:
'Put *Impression*'."[21]

Impression, Soleil levant (Impression, Sunrise), Louis
Leroy, a journalist on *Charivari,* read on the brochure:
"I was sure about the Impression. And I said to myself,
since I am impressed, there must be an impression
somewhere in there. (...) And what freedom, what ease
in the treatment! Wallpaper in its embryonic state is
more finished than that seascape!" The critic made a
malicious play on the word, giving his article published
on 25 April 1874 the title "L'Exposition des Impres-
sionnistes" (The Impressionists' Exhibition), so quite
inadvertently giving a name to the movement that was
to overturn established ideas in the second half of the
19th century.

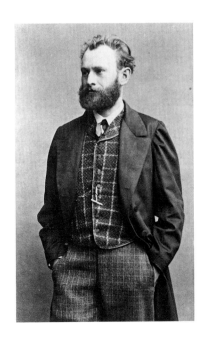

A piece of sarcasm gave rise to a celebrated name: the
reactions were certainly very lively, but there was noth-
ing reassuring for the conformists about seeing other
troublemakers, like the naturalist writers Duranty and
Zola, giving their support to the new school, at least in
its early days. At that period any revolution, even an

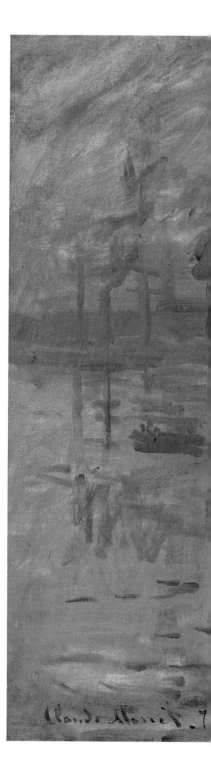

aesthetic one, seemed extremely threatening to the middle-class public who had not yet recovered from the rebellion of the Commune and feared for its scarcely regained security. But *Impression, Soleil levant* (Impression, Sunrise) was going to become the emblem of the Impressionist movement.

Immediately the group's exhibition closed, *Impression, Soleil levant* (Impression, Sunrise) found a taker: a man by the name of Hoschedé, a young, prosperous businessman who owned a shop called *Au Gagne-Petit*. Through the agency of Monet's dealer, Paul Durand-Ruel, he bought the picture for the sum of eight hundred francs. Some time later it passed into the hands of a rich Romanian, an art enthusiast and a doctor who generously advised and attended to his penniless painter friends for years. Monet and he became very close. Apart from the care he lavished on them, purchases of several pictures and generous advances, it was to de Bellio that Monet turned on the death of his wife Camille to redeem a piece of jewellery which he wanted her to wear from a pawn shop.

<

Claude Monet's account book
1872-1875

MMM Archives
inv. 5160

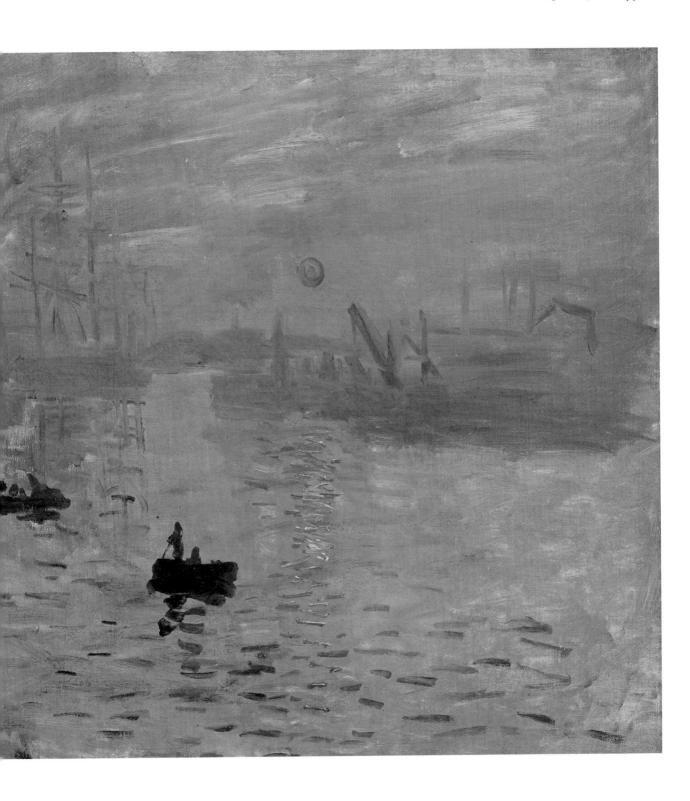

∧ <
Le Pré bordé d'arbres
(Meadow lined with trees)

Pastel heightened with gouache
22 × 37 cm
Michel Monet Bequest, 1966
Inv. 5003

∧
Impression, Soleil levant
(Impression, Sunrise)
1872

Oil on canvas
48 × 63 cm
Victorine Donop de Monchy Bequest, 1957
Inv. 4014

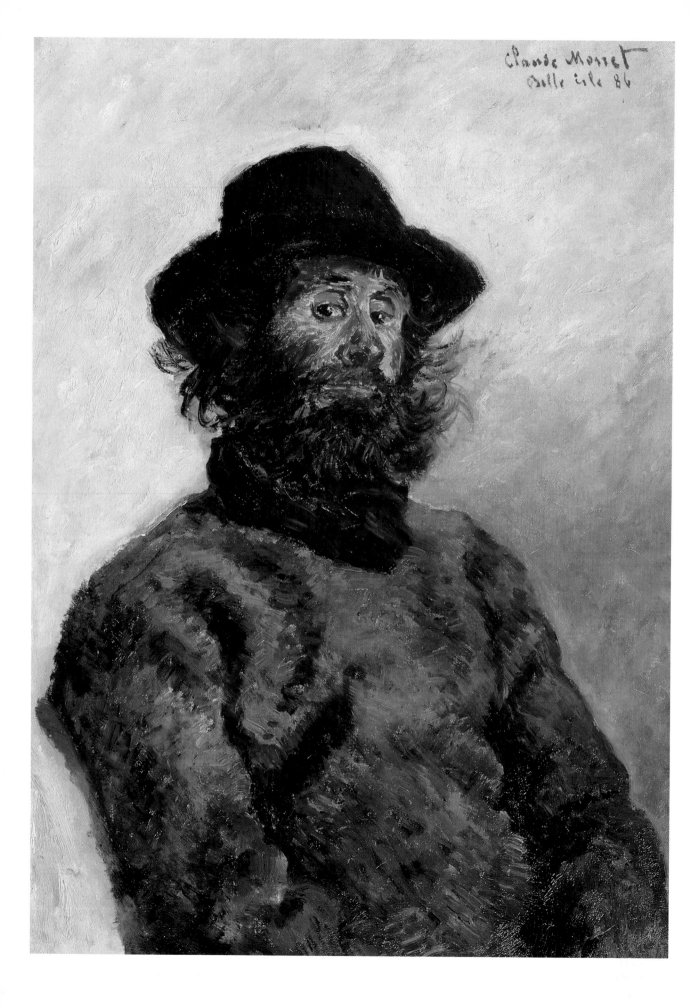

Figures and silhouettes

Before becoming almost exclusively a landscape painter, Monet practised every genre of painting. But he was wary of commissioned portraits, preferring to choose his models from among his close friends and family.

Camille sur la plage
(Camille on
the beach)
1870

Oil on canvas
30 × 15 cm
Michel Monet Bequest, 1966
Inv. 5038

<
Portrait de Poly
(Portrait of Poly)
1886

Oil on canvas
74 × 53 cm
Michel Monet bequest, 1966
Inv. 5023

If we think of the almost 2000 pictures catalogued, few figures stand out in his work apart from members of his family. Camille whom he married in 1870 was first Monet's model. Posed as a woman of the world, in Japanese dress, on the beach, or in an interior, she would gradually lend herself to a role as a more anonymous figure in the landscape, an instrument for pictural experiment, a counterpoint, very frequently as an arabesque silhouette in the gardens or countryside at Argenteuil.

In the work of Monet the figure was destined to lose out to subjects allowing him to satisfy his primary emotion, the play of light on matter. "It is the obsession, the torment, the joy of my days," he confessed to Clemenceau when the latter wanted to console him for not being able to attain a goal that was in reality inaccessible, in launching himself like "a projectile towards the infinite". To such an extent "that one day, finding myself at the bedside of a dead person who had been and still was very dear to me (Camille) I caught myself, my eyes fixed on her tragic forehead, in the act of automatically looking for the sequence and adaptation of the losses of colour which death had just imposed on the motionless face. The desire to reproduce the final image of the woman who was going to leave us for ever [was] quite natural (...). But there (...) my reflexes were involving me, in spite of myself, in an unconscious operation in which the daily course of my life was being resumed."[1]

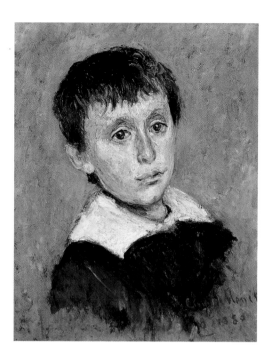

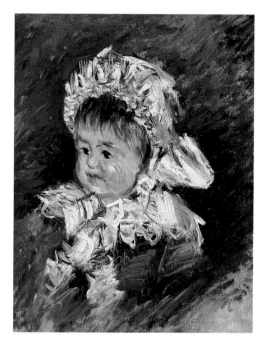

∧
*Portrait de Jean Monet
(Portrait of Jean Monet)*
1880

Oil on canvas
Michel Monet Bequest, 1966
Inv. 5021

>
*Portrait de Michel Monet, bébé
(Portrait of Michel Monet as a baby)*
1878

Oil on canvas
46 × 37 cm
Michel Monet Bequest, 1966
Inv. 5014

∨
*Michel Monet et Jean-Pierre Hoschedé
(Michel Monet and Jean-Pierre Hoschedé)*
1881

Pastel
54 × 73 cm
Michel Monet Bequest, 1966
Inv. 5060

> >
*Portrait de Michel
en bonnet à pompon
(Portrait of Michel in a pompom hat)*
1880

Oil on canvas, 46 × 38 cm
Michel Monet Bequest, 1966
Inv. 5018

Likewise, Monet seldom painted his two sons, although he did for example do a *Portrait de Michel en bonnet à pompon* (Portrait of Michel in a pompom hat) in 1880 and one of his elder son, *Jean Monet*. Following the death of their mother, the brothers were brought up by Alice Hoschedé whom their father married in July 1892. Jean died young in 1914 just before the outbreak of war. Michel, the younger brother, kept his father company until his final day and was the sole recipient of all the pictures kept at Giverny and non-pecuniary copyright in his work. He was fascinated by Africa and the primitive arts, and also became an enthusiast for safaris, enjoying telling tales of his "elephant" hunts.

Among the few portraits, one of the most unusual is undoubtedly the head-and-shoulders portrait of Poly, painted in 1886 when Monet went alone to discover the harshness of the ocean at Belle-Île-en-Mer. In the hamlet of Kervilahouen where he found lodgings "near the place called the Terrible Sea, (..) sinister, devilish, but superb",[2] he made the acquaintance of Hippolyte Guillaume, "an old sailor, a real character", a countryman with a variety of jobs, a baker, a sea dog, or again a gardener, who became his accredited porter and his model for two francs a day. "I got old man Poly to pose and I made a good quick sketch of him, a very good likeness; the whole village had to see it, and the nice thing

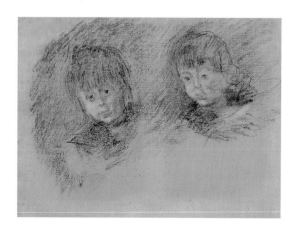

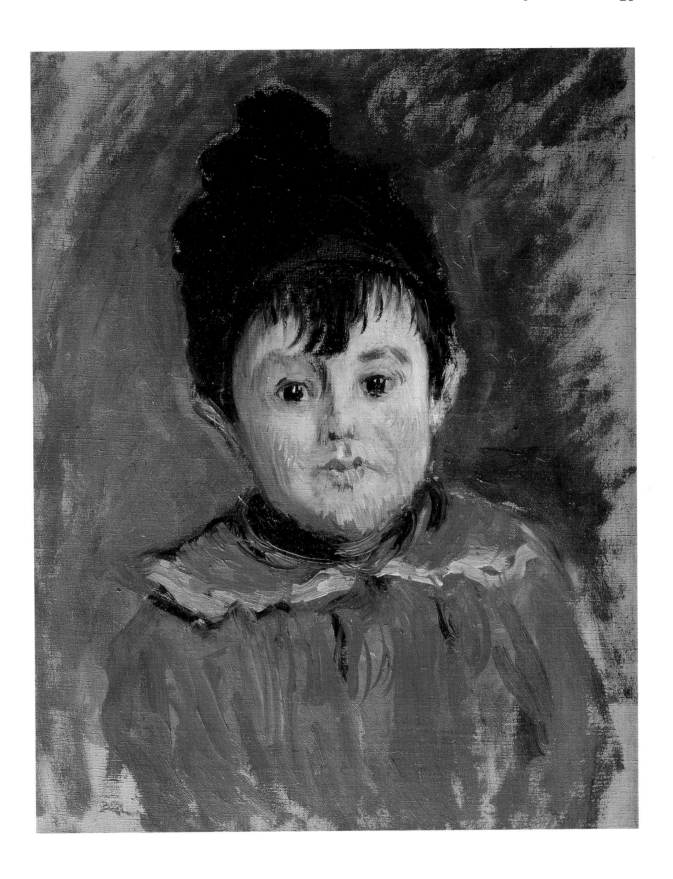

is that everyone complimented him on his good fortune, thinking I'd done it for him, so that I'm not quite sure how to get out of it. Anyway you'll see the type; he's another kind of jack-in-the-box a bit in the style of old Paul."[3]

In addition to the study of the faces of those he loved, or sometimes of picturesque characters, Monet was just as parsimonious about depicting himself: three self-portraits are the sum total of those known. Wearing a beret on his head or sitting in his studio, he seemed to Clemenceau "fully self-possessed, ready to go into action. He has seen, he has understood, he has made up his mind, he is progressing towards a supreme purpose".[4] But except for the final self-portrait painted in 1917 (Paris, Musée d'Orsay), he abandoned the figure once and for all in 1895 to devote himself exclusively to plein-air painting.

∧
Tête de femme
(Woman's head)
1862

Oil on canvas
52 × 41 cm
Michel Monet Bequest, 1966
Inv. 5126

>
L'Artiste dans son atelier
(The artist in his studio)
1884

Oil on canvas
54 × 48
Gift from Daniel Wildenstein, 1986
Inv. 5187a

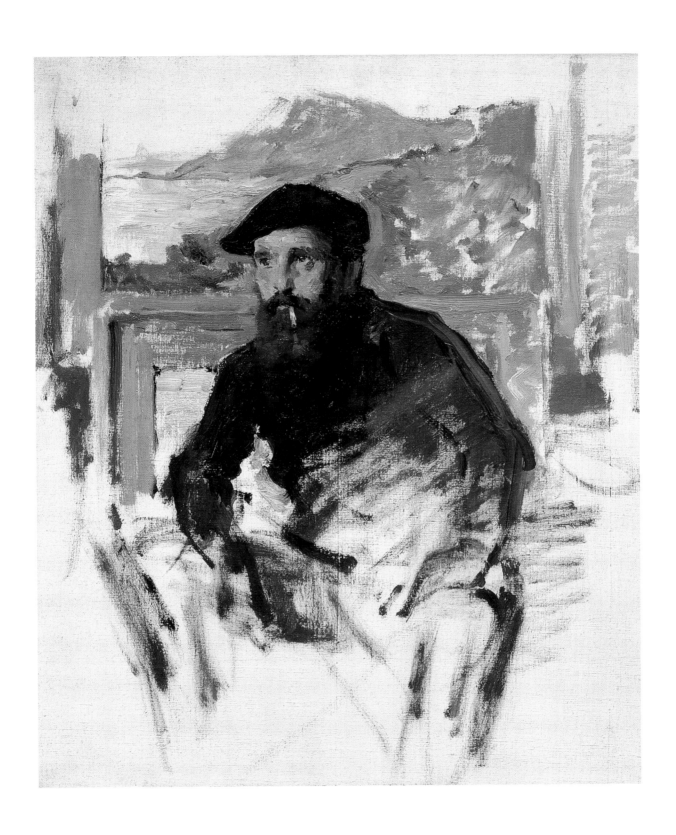

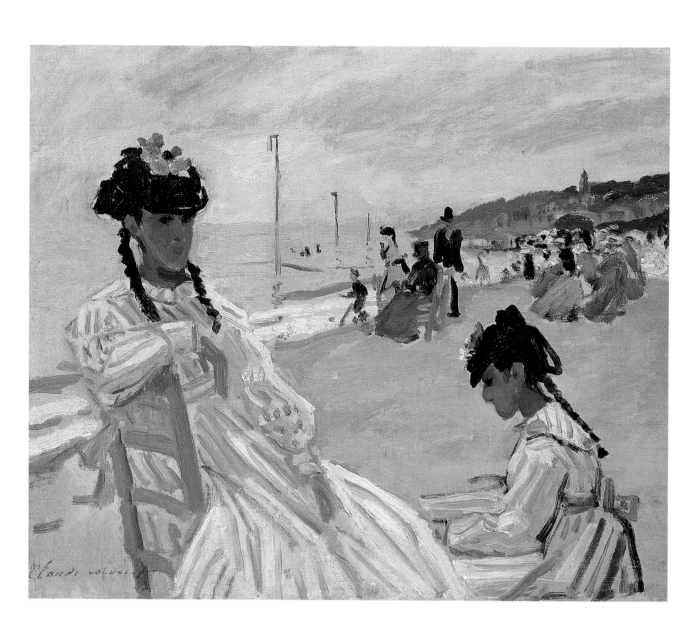

Beside water

Water was fundamental in his work as a whole, and took Monet further in his innovative approach. It always dazzled the artist, down to his final desire for his body to be "buried in a buoy"[1] on his death and cast into the sea.

Monet often changed his address, sometimes to alleviate financial difficulties, but also to keep up with his discoveries. The Seine is the connecting link between his places of residence. From the Île-de-France to the Norman coast, he always set up house beside the river. From his childhood in Le Havre to his move to Giverny, he never really left the estuary or the winding course of the Seine.

He is "the painter of water par excellence", as Théodore Duret writes. "In the work of Monet, it no longer has a constant colour of its own, it takes on an infinite variety of appearances which it owes to the state of the atmosphere, the nature of the background against which it moves, or the silt it carries in it; it is limpid, opaque, calm, troubled, flowing or dormant, according to the momentary look the artist finds on the liquid expanse before which he has set up his easel."[2]

Adventures at Trouville

In 1870, after a failure at the Salon and his very quickly arranged marriage, Monet went with his young wife Camille and their three-year-old son Jean, to this holiday resort which was very fashionable in the Second Empire period. He found an atmosphere conducive to his work and brush on the boards in front of the Hôtel des Roches

<

Sur la plage à Trouville
(On the beach at Trouville)
1870

Oil on canvas
38 × 46 cm
Michel Monet Bequest, 1966
Inv. 5016

∧
Le Printemps à travers les branches
(Spring through the branches)
1878

Oil on canvas
52 × 63 cm
Victorine Donop de Monchy Bequest, 1957
Inv. 4018

∨
Le Bateau-atelier à l'île aux Orties
(The studio boat at the Île aux Orties)

Monet's sketchbook
Michel Monet Bequest, 1966
Inv. 5131

Noires, in seascapes and the people strolling along the huge sandy beach.

But this carefree semblance was only apparent in view of the dramatic political situation. On the declaration of war, he decided to cross the Channel. He stayed in London for some months, then travelled across Holland, returning to France only after the bloody events of the Commune. After a short period in Paris, he left the capital to take up residence in the small town of Argenteuil, famous for boating and its regattas, and linked to the city by rail.

Argenteuil, at the peak of Impressionism
Monet stayed there for six years, moving house once in 1874 from the Maison Aubry to the Pavillon Flament. He painted the surrounding sites, the fields where Camille and Jean sometimes roamed, views of the river, downstream and upstream, in all weathers. From the river bank he depicted the railway bridge with its double columns. Some views were also studied from the Île de la Grande Jatte, between Neuilly and Courbevoie; from there he recorded the reflections on the Seine through a curtain of foliage.

To satisfy his anxiety to observe, his need to get as close as possible to his subject more fully, it was necessary to paint on the water: "a profitable sale brought into my pocket at one fell stroke enough money for me to buy myself a boat and make a cabin on it from boards where I had just enough room to set up my easel."[3] This boat-studio was fitted out thanks to the advice of Gustave Caillebotte, an enthusiastic and knowledgeable yachtsman and future president of the Petit-Gennevilliers sailing club.

He painted unremittingly, employing only light colours to achieve an incomparable luminous intensity through effects of values: colour was set free. *Promenade près d'Argenteuil* (Walk near Argenteuil) sets the scene of a happy time. The canvases of that period reflect a great serenity which seems not to have been ruffled by the precariousness of his situation. His fellow students came to share in the quietude of the moment. Renoir came to stay, Manet and Sisley were visitors. They all came to sample the pleasure of painting the fields and gardens

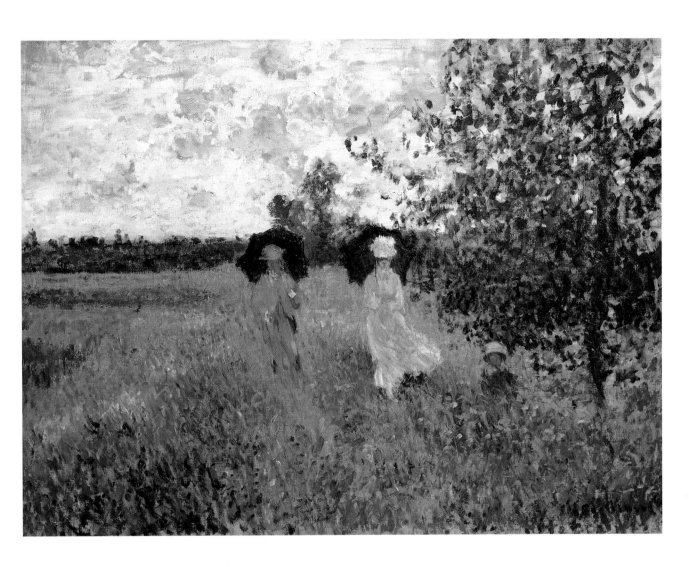

∧
Promenade près d'Argenteuil
(Walk near Argenteuil)
1873

Oil on canvas
60 × 81 cm
Michel Monet Bequest, 1966
Inv. 5332

>
Le Pont de chemin de fer. Argenteuil
(The railway bridge. Argenteuil)
1874

Oil on canvas
14 × 23 cm
Michel Monet Bequest, 1966
Inv. 5037

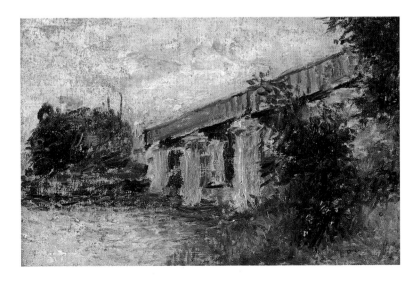

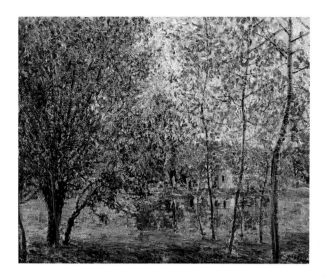

∧
Alfred Sisley
(1839-1899)
Le Canal du Loing au printemps
(The Loing canal in spring)
1892

Oil on canvas
53 × 66 cm
Nelly Sergeant-Duhem Donation, 1985
Inv. 5331

∨
Auguste Renoir
(1841-1919)
Portrait de Claude Monet
debout
(Portrait of Claude Monet,
standing)
1875

Pastel
44 × 33 cm
Michel Monet Bequest,
1966
Inv. 5066

>
Vétheuil dans le brouillard
(Vétheuil in the fog)
1879

Oil on canvas
60 × 71 cm
Michel Monet Bequest, 1966
Inv. 5024

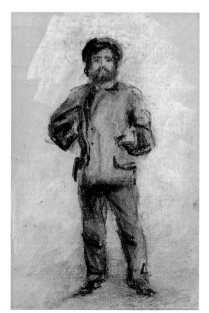

where there was a profusion of flowers, and together they painted Camille and Jean in the garden .

Vétheuil

After a brief return to Paris and the birth of Michel, in 1878 Monet moved to Vétheuil with the Hoschedé family. Ernest Hoschedé, one of the first patrons and collectors of Impressionist paintings, had met Monet in 1874 during the exhibition at the Nadar gallery, and owned a few works by the painters rejected by the Salon, bought from their dealer Paul Durand-Ruel a year earlier. He had been interested in painting since 1870 at least, a period when we know that he borrowed a picture by Boudin and later bought one by Corot. In 1876, he invited Monet to his château at Montgeron to carry out decorative works for it. But Hoschedé soon experienced major commercial setbacks, and finally went resoundingly bankrupt. The château was sold, the pictures auctioned. The Hoschedé and Monet families joined forces at Vétheuil where they rented a villa together to face up to their shared pecuniary difficulties. With twelve of them, two couples and eight children, they were on top of one another, not counting the private governess, the nanny, and the cook, though it would soon be necessary to part with them.

In spite of these special circumstances, Monet liked it in this village which forms the arc of a circle at the foot of the cliffs on the right bank of the Seine. "You perhaps knew," he wrote to the pastry-cook Murer, "that I had set up camp beside the Seine at Vétheuil, in a beautiful spot from which I could bring back quite a few good things if the weather was better."[4] In particular he composed a view of *Vétheuil dans le brouillard* (Vétheuil in the fog) which he offered the opera singer Jean-Baptiste Faure, who was already at the height of his fame. The baritone's passion for art and his liking for speculation prompted him first to buy works by the Barbizon painters, then numerous paintings by their successors. He bought primarily works by Manet, eventually owning sixty-seven pictures by him.

As for Monet, in one of his account books he recorded more than nineteen works that went to this buyer. However, Faure refused the *Vétheuil* on offer, despite its

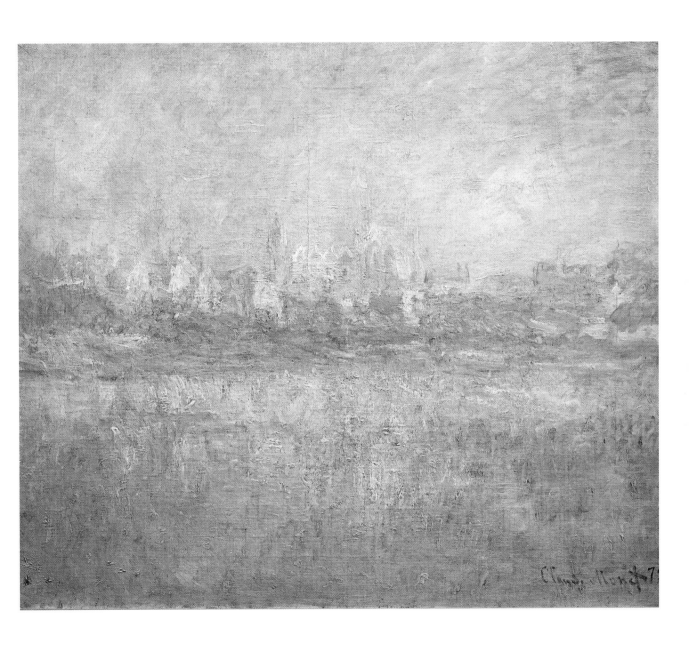

∧
*Vétheuil vu depuis
l'île Saint-Martin
(Vétheuil seen from
the Île Saint-Martin)*
Page from a sketchbook
24 × 31 cm
Michel Monet Bequest, 1966
Inv. 5130

>
*La Plage à Pourville.
Soleil couchant
(The Beach at Pourville.
Sunset)*
1882

Oil on canvas
60 × 73 cm
Michel Monet Bequest, 1966
Inv. 5008

> >
*Falaise et Porte d'Amont.
Effet du matin
(Cliff and Porte d'Amont.
Morning effect)*
1885

Oil on canvas
50 × 61 cm
Michel Monet Bequest, 1966
Inv. 5010

modest price of fifty francs, considering it too pale. Monet was annoyed: "I was in my little boat early, waiting for the light effect. The sun came out, and at the risk of displeasing you I painted what I saw."[5] Many years later, Faure saw the canvas again and this time wanted to buy it, but Monet refused. And he kept it lovingly.

Since the birth of Michel, Camille's delicate health had constantly deteriorated. She died on 5 September 1879, at the age of thirty-two after a long illness. Monet was very upset. Family life was confused, Ernest Hoschedé was almost always away, trying in vain to rebuild his empire. His wife Alice, who had looked after Camille for a long time and taken care of all of them, played an ever more important role in the artist's life. She would choose to remain with him for good.

Pourville

Monet often felt the need to return to his childhood stamping ground to "soak up the sea air again"[6], the backdrop of his existence. In spite of being devoted to them, he often left his wife and children to return to the Norman coast. In February 1882 he was at Pourville. In one of his daily letters to Alice, he noted that "The countryside is very beautiful and I really regret not having come here sooner rather than wasting my time at Dieppe. It would be impossible to be closer to the sea than I am, right on the shingle, and the waves beat against the foot of the house."[7]

That same year, to escape for longer from Poissy where he lived for a short time but which still failed to inspire him, he went back to the small seaside resort. He rented the Villa Juliette and spent the summer with Alice and the eight children. From the beach at the foot of the cliff he painted *La Plage à Pourville. Soleil couchant* (The Beach at Pourville. Sunset). Monet brought back a hundred or so canvases from these two Norman trips.

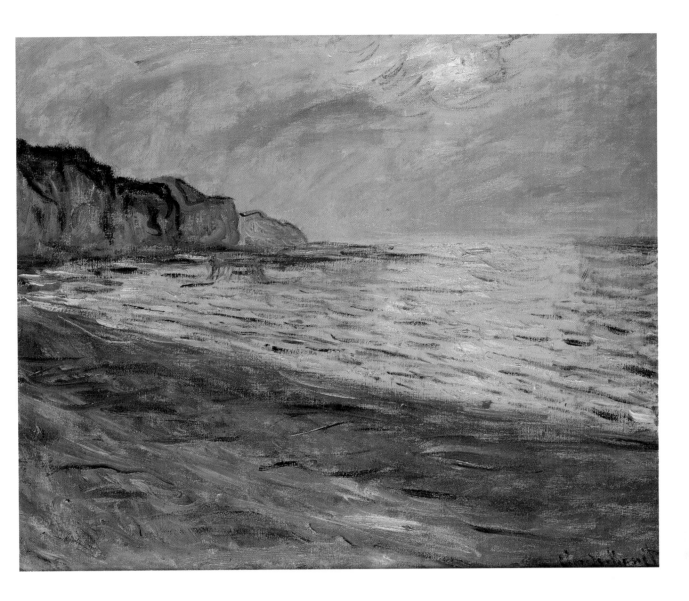

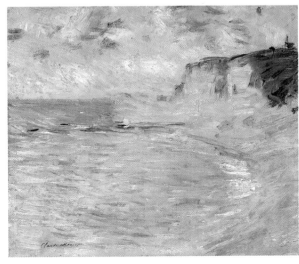

<
The Villa Juliette at Pourville
Old post card
MMM Archives

The cliffs at Étretat

On his visits to Le Havre, Monet often escaped to the
coast of the Caux region, going to the rocky walls of
Étretat. Like Courbet, Boudin, Degas and Whistler, he
was fascinated by the beauty of the place. He depicted
the cliffs towering above the sea "though it is exceed-
ingly bold of me to do so after Courbet who did it
admirably".[8] In autumn 1885 the painter was back in
Étretat, in a house lent to him by Jean-Baptiste Faure.
He resumed his painting, this time taking an interest in
the fishing boats at rest on the shingle or at sea with
their sails swollen by the wind.

While there he spent some time with Guy de
Maupassant whose naturalist sensibility brought him
close to the new painting; he often gave Impressionist
overtones to his descriptions of places in his novels. They
spent several days together, and sometimes ate together
in the evening, but Monet, while he admired the writer,
was critical of some of his opinions about painting:
"as he doesn't understand much about it and often
annoyed me, I was a bit forceful, perhaps a bit too much

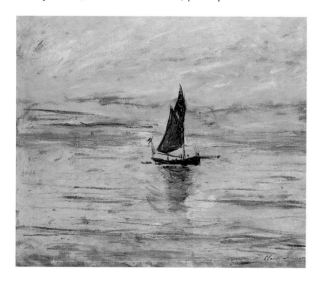

V <
Le Voilier. Effet du soir
(Sailing ship. Evening effect)
1885

Oil on canvas
54 × 65 cm
Michel Monet Bequest, 1966
Inv. 5171

V
La Falaise d'Étretat
(The Étretat cliff)
c. 1885

Pastel
21 × 37 cm
Michel Monet Bequest, 1966
Inv. 5034

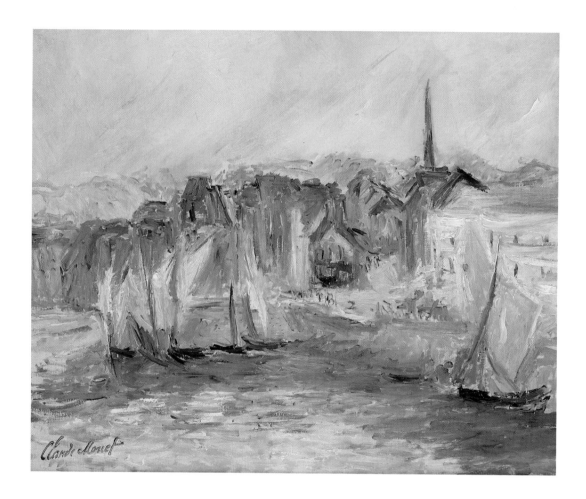

so, to such an extent that this morning he packed his bags and has just left."[9] The novelist would remember long walks with a "Claude Monet in pursuit of impressions (who) in reality was no longer a painter, but a hunter. He would walk along followed by children who carried his canvases, five or six canvases depicting the same subject at different times of day and with different reflections."[10]

Honfleur and its memories

In October 1917, in great distress, to escape from his profound loneliness Monet turned to his work with redoubled ardour. At the age of seventy-seven, he was often exhausted and disheartened in face of the challenge he had set himself. The work involved in the *Grandes décorations* (Giant decorations) project sometimes proved to be beyond his strength. "I am literally haunted by what I have taken on."[11] Then he again felt the need to seek renewed vitality in Normandy. "Here I am back home now, delighted with my little trip where I resaw and relived so many memories, so much hard work. Honfleur, Le Havre, Etretat, Yport, Pourville and Dieppe, it did me good."[12] He brought back a few studies and returned from his tour reinvigorated: "I am back home now, and very content with this short trip where I saw and resaw beautiful things which brought back so many memories"[13], such as the times at the Ferme Saint-Siméon and the long excursions in the company of Boudin and Jongkind to discover or rediscover seaside panoramas.

<
Bateaux dans le port d'Honfleur (Boats in Honfleur harbour)
1917

Oil on canvas
50 × 61 cm
Michel Monet Bequest, 1966
Inv. 5022

∧ ∧
Falaise à Pourville (Cliff at Pourville)

Monet's sketchbook
Michel Monet Bequest, 1966
Inv. 5134

∧
Le Bateau-atelier (The studio boat)

Monet's sketchbook
Michel Monet Bequest, 1966
Inv. 5130

>
Barques à Étretat (Boats at Étretat)

Monet's sketchbook
Michel Monet Bequest, 1966
Inv. 5131

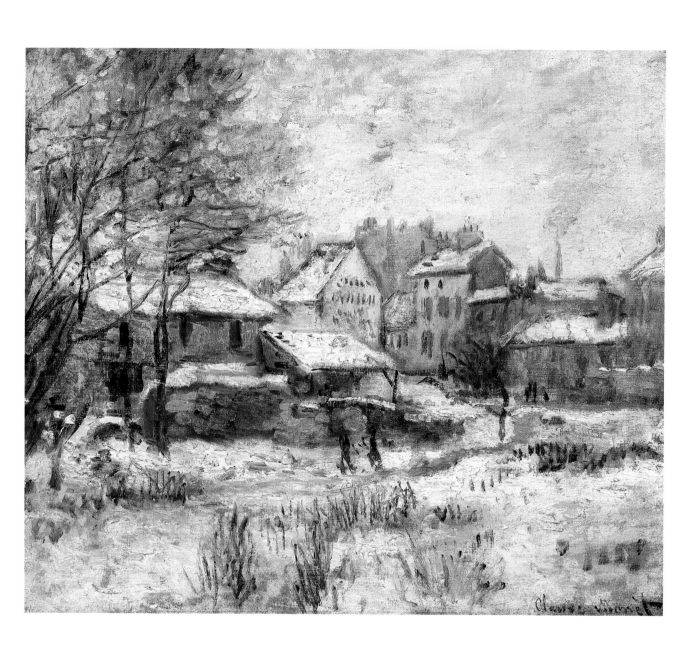

Snow effects

Monet wished to seize the light, capture its rays and the variations they give rise to on the subject, and "convey (his) impressions before the most fleeting effects". Thus winter was the source of new harmonies to break down and transpose on to his canvas.

As early as 1865 he worked on a first landscape under snow, a view of the road from Trouville to Honfleur. He was eager to note the subtle changes in the atmosphere, making us feel the weight of winter with as much ease as he lets us savour the lightness of spring. The density of the whites contrasts with the blue of the shadows, a delight we find again in *Effet de neige. Soleil couchant* (Snow effect. Sunset).

During the winter of 1874-1875, he worked on a series of views of Argenteuil covered in a mantle of white. In or around the village, his scenes are almost always enlivened by small figures who disrupt the stasis of winter. In them we find, Octave Mirbeau notes, "the same eloquence of treatment looking at his winter landscapes which the cold makes icy, and the snow covers with its grey, yellow, pink or blue blanket; looking at his trees with their hoar-frost beards".[1]

During the same winter working session, he also set up his easel on the platform of the station linking the small town to the capital, and Parisians to this leisure resort. *Le Train dans la neige* (Train in the snow) stops at the station where a few passengers are busy on the platform. The engine belches out its smoke which blends into a sky as cold and grey as the snow covering the track. The subject of this work presages the famous views of the

<

Effet de neige. Soleil couchant
(Snow effect. Sunset)
1875

Oil on canvas
53 × 64 cm
Victorine Donop de Monchy Bequest, 1957
Inv. 4019

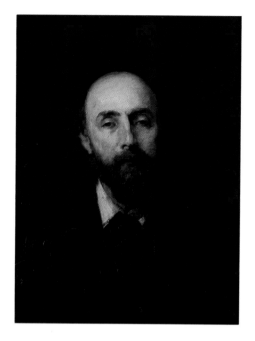

Gare Saint-Lazare painted in 1877. Dr de Bellio, one of Monet's first benefactors, managed to buy this picture. "Please keep the Railway Engine for me, my dear friend, unless you are keeping it for yourself; but don't let anyone else have it. There is a little conspiracy connected with this which I discovered and I'll tell you about it next time I see you; a conspiracy that would have the effect of letting it fall into the hands of a fool. It would be a real move in the wrong direction, as you see."[2]

In 1883 the happy owner lent his painting for a Monet retrospective organized by the Galerie Durand-Ruel. It attracted a great deal of attention from the critics: "See his Train. The engine stops, panting, still vibrating with the impetus given, releasing the overheated steam; only its two front lights pierce the mist, like two wide-open yellow eyes; on the platform of the little station the faint silhouettes of the employees stamping their feet, the peaks of their caps lowered, their faces chapped so that they look green, their hands thrust numbly into their pockets."[3]

∧
Nicolas Jan Grigorescu
(1838-1907)
Portrait de Georges de Bellio
(Portrait of Georges de Bellio)
1876

Oil on canvas
71 × 54 cm
Victorine Donop de Monchy Bequest, 1957
Inv. 4294

>
Giverny sous la neige
(Giverny in the snow)

Monet's sketchbook
Michel Monet Bequest, 1966
Inv. 5129

> >
Le Train dans la neige. La locomotive
(Train in the snow. The engine)
1875

Oil on canvas
59 × 78 cm
Victorine Donop de Monchy Bequest, 1957
Inv. 4017

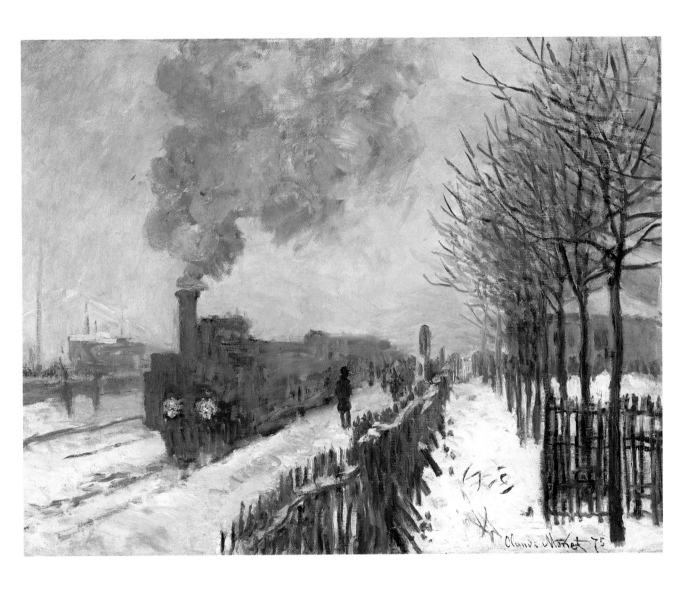

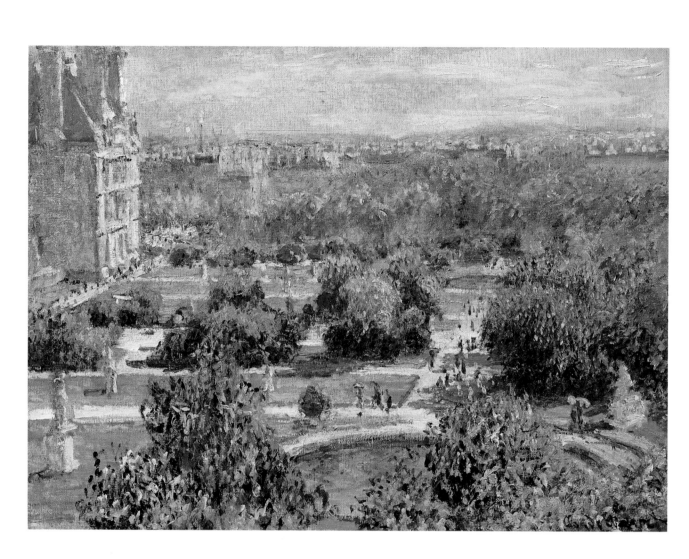

Townscape painter

First and foremost a landscape painter, Monet exalts nature, but he is also attracted by certain aspects of town life, bearing witness to the modernity of the century: green spaces recently embellished by the pomp of the Third Republic, the tumult and comings and goings of passers-by on the wide boulevards, railway stations.

<
Les Tuileries
(The Tuileries gardens)
1876

Oil on canvas
54 × 73 cm
Victorine Donop de Monchy Bequest,
1957
Inv. 4016

The Tuileries, a public garden in the heart of the capital very popular for its elegant walks, delighted Manet, Pissarro and many other artists. From the flat of the collector Victor Chocquet at 198 rue de Rivoli, Monet undertook a series of four bird's-eye views of *Les Tuileries* (The Tuileries gardens). The one now held at Marmottan, shown in April 1877 at the third Impressionist exhibition along with eight paintings of the Gare Saint-Lazare, inspired Émile Zola when he described the canvas started by Claude Lantier, the main character in his novel *L'Œuvre,* published in 1886: "The Tuileries, in the background, disappeared in a golden haze, the pavements were blood red, the passers-by were no more than indications, dark patches eaten up by the excessive brightness."[1]

The Gare Saint-Lazare
Monet often took the train for Argenteuil or Normandy from the Gare Saint-Lazare. Fascinated by the lively bustle of the place and its glass and metal architecture, he left his family to take up residence a few times at 17 rue Moncey, in a studio rented by his friend Caillebotte.
His idea was to carry out several compositions in order to paint this monument of modernity from different points of view. He obtained permission to work right inside the

building, under the imposing glass roof, so as to convey the activity more accurately. He also took up position farther away, opposite the metal structure of the Pont de l'Europe, and recorded the engines with their plumes of steam. Faithful to his normal practice, he made several preparatory drawings in his sketchbooks. In pencil he picked out perspectives and bold outline framing, covering the pages with notes that would be used later for his oil paintings.

Émile Zola was enthralled by these paintings: "This year Monet has exhibited superb station interiors. You can hear the roar of the trains pulling in, see the excesses of smoke swirling under the huge roofs of the station buildings. This is painting today."[2]

Rouen cathedral

In 1892 Monet decided this time to tackle the majestic architecture of Rouen cathedral. After several studies made from different viewpoints, his choice settled on the west door. He set up his studio in a novelties shop, and was hidden from the customers by a screen. There, behind the window, he doggedly scrutinised the atmospheric variations and their effects on the stone.

The letters he exchanged with Alice attest to the scale of the challenge. "I work like a black, today 9 canvases; you can imagine how tired I am, but I'm bowled over by Rouen. (…) I'm shattered, I can't do any more, and, something that never happens to me, I've had a night full of nightmares: the cathedral was falling on top of me, it seemed either blue or pink or yellow. (…) I'm fully aware of the state I'm in, I've the pride and self-esteem of the devil, I want to do better, and I'd like these Cathedrals to be really good, and I can't, I grope around and slave over the same research to the detriment of many things, and when I have to accept after days of work that I'm not a step further forward, I just have to

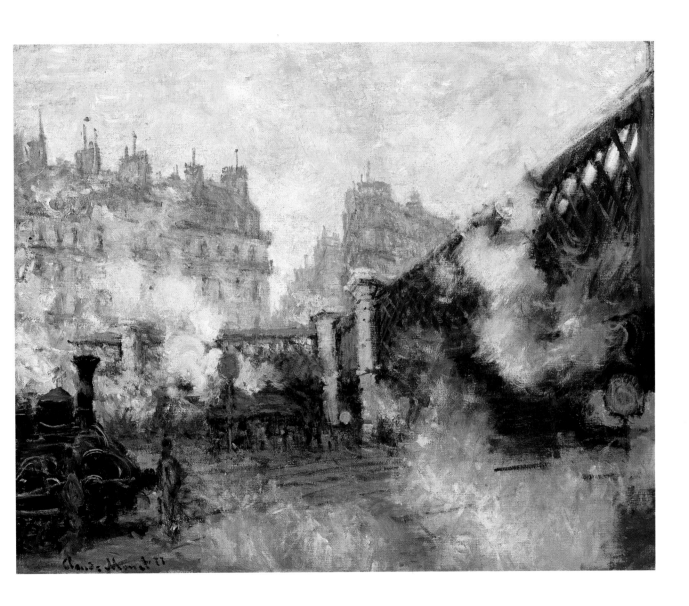

∧ ∨

*Portail et façade
de la cathédrale de Rouen
(Main door and
façade of Rouen Cathedral)*
Monet's sketchbook
Michel Monet Bequest, 1966
Inv. 5134

>

*Cathédrale de Rouen.
Effets de soleil. Fin de journée
(Rouen Cathedral. Sunlight
effects. End of day)*
1892
Oil on canvas
100 × 65 cm
Michel Monet Bequest, 1966
Inv. 5174

face the facts."[3] This dogged work reached its culmination at the end of two years. The Galerie Durand-Ruel exhibited twenty versions of the cathedral, twenty canvases of the same subject in which the painter succeeds in making us understand and discover the reality of light on matter, the natural and harmonious symbiosis of the elements at different times of day.

On the whole critical reaction was favourable to the enterprise and some critics finally recognized Monet's genius, like Clemenceau in his article entitled "Révolution de Cathédrales": "What will the subject be under this fury of living atoms through which it can be glimpsed, through which it is visible to us, through which, for us, it truly is? That is what now needs to be known, what needs to be expressed through painting, what has to be decomposed by the eye and recomposed by the hand. (...) How can the artist, a few centimetres away from his canvas, understand an effect that is both precise and subtle which can only be appreciated from a distance? That is the disconcerting mystery of his retinal screen."[4] *Le Portail vu de face. Harmonie brune* (The portal, front view. Harmony in brown) (Paris, Musée d'Orsay) was the first work by the artist to be bought by the State – but fifteen years later, in 1907.

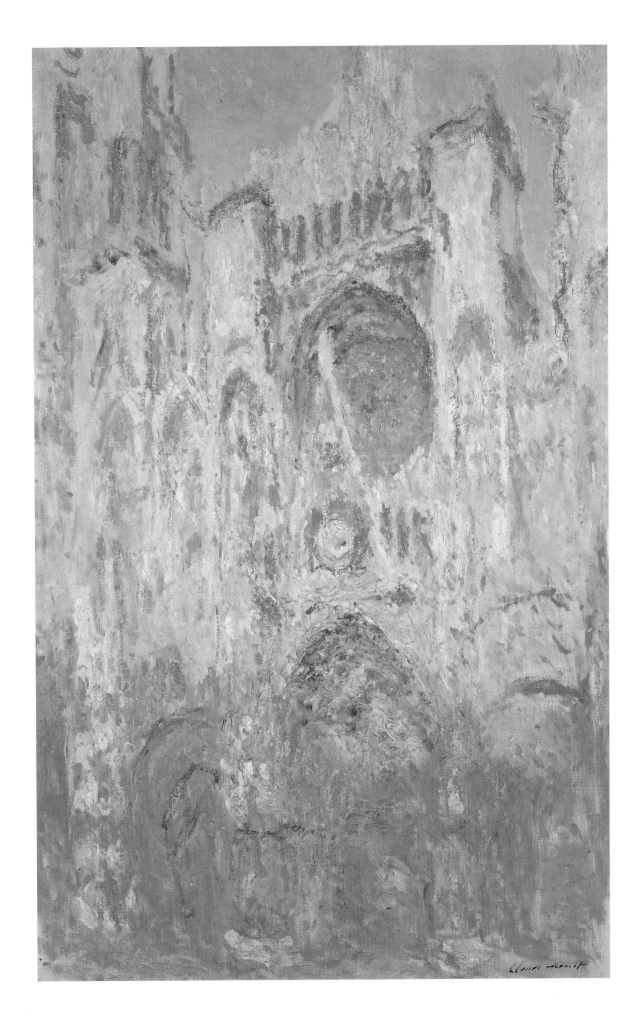

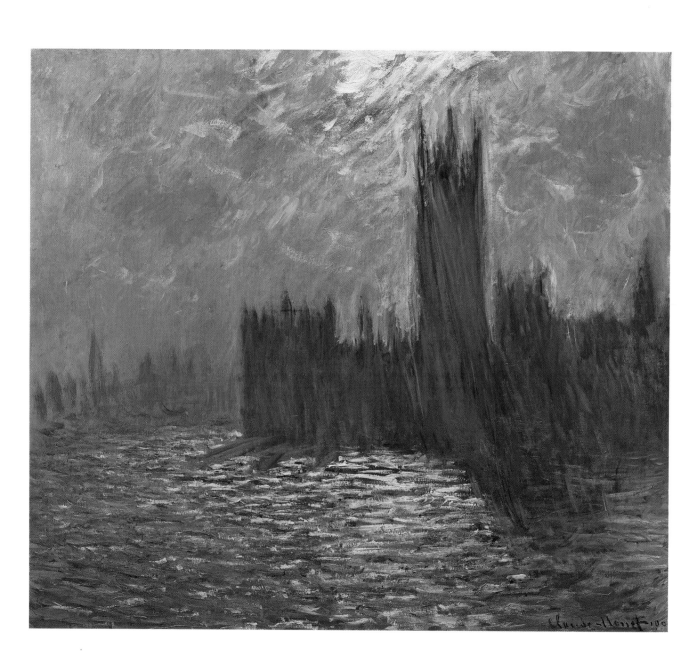

Travel

Always eager to experience different light effects, "horizons we have no concept of"[1] fired the inspiration of Monet, who with touching humility was unfailingly enthusiastic about the wonders of nature.

While new subjects and new colours would take Monet to the areas surrounding Paris, the Norman coast or beyond the frontiers of France, his first journey was not for pleasure. After enrolling for seven years, he set off for Africa in 1861 to join the 1st light cavalry regiment. He fell ill and was sent back to the home country the following year for a few months' convalescence. Thanks to his aunt who "bought the young man out", he was released before serving his full term. There is no remaining trace of this journey except for the recollection recounted at the end of his life to Thiébault-Sisson:"To start with I didn't realise. The impressions of light and colours I received over there did not fall into place until later; but the seeds of my future researches lay there."[2]

London and its diaphanous mists

Monet's departure abroad in 1870 was prompted by the political situation. He decided to leave France which was at war, and took the boat for England. "I experienced poverty there too. England wanted none of our paintings."[3] But there through the agency of Daubigny, he became acquainted with a dealer: "And for us Durand-Ruel was the saviour. For fifteen years and more, my painting as well as Renoir's, Sisley's and Pissarro's had no other outlet than through him."[4]

From this first visit to London, Monet brought back a few landscapes. And for years he hoped to return:

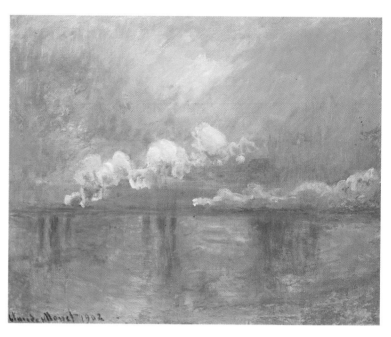

∧
Charing Cross Bridge.
Fumées dans le brouillard.
Impression
(Charing Cross Bridge.
Smoke in the fog.
Impression)
c. 1899

Oil on canvas
73 × 92
Michel Monet Bequest, 1966
Inv. 5001

∨
Charing Cross Bridge
c. 1899

Oil on canvas
60 × 100
Michel Monet Bequest, 1966
Inv. 5101

>
Waterloo Bridge
c. 1900

Pastel
30 × 47 cm
Michel Monet Bequest, 1966
Inv. 5048

"I'm expecting to come to London. (...) I'd even like to try to paint some fog effects on the Thames,"[5] he wrote to Duret in 1887. In spite of two return trips, he would not really fulfil his wish until thirty years after his first stay in the British capital. He went there three times between 1899 and 1901, once with his wife while his son Michel was living in London to perfect his English.

For Monet these journeys had in fact only one objective, painting the thick fogs that enveloped the famous buildings and merged with the vapours rising from the river. "A single theme in these pictures, single, yet diverse: the Thames."[6] Thus started the symphony of views of the Houses of Parliament, Charing Cross Bridge and Waterloo Bridge, seen from his bedroom at the Savoy Hotel or from the terrace of St Thomas's Hospital. Paintings with which Monet immediately felt satisfied were few and far between. Once back in France, he retouched most of them, then took them back to London to complete. On his return to Giverny, he did more work on the group of what he himself announced as a series. He did not part with any of the paintings, as some were needed to complete others. Whatever their theme, the real analysis carried out by the artist relates to the appearance the motif takes on under the effect of the vagaries of the climate. Charing Cross Bridge or the Houses of Parliament form an outline in the phantasmagoric atmosphere of the fog. Nearly a hundred

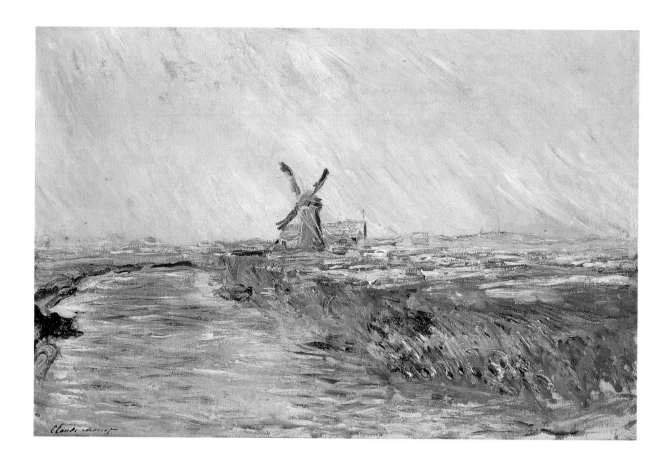

canvases were executed in this way based on the Thames and its reflections. They were presented in 1904 at the Galerie Durand-Ruel: "The work is prodigious. There is no other word for it."[7]

Holland

After taking refuge in England, the artist and his family extended their period of exile in Holland in 1871, before rejoining France. "I'm wonderfully well placed here for painting," Monet wrote to Pissarro on his arrival; "it's the greatest fun imaginable. Houses of all colours, mills by the hundred and beautiful boats."[8] He was to see the country again in 1886 in very different circumstances. Invited by Baron d'Estournelles de Constant, an embassy secretary with the French legation in The Hague, he went there in the spring to appreciate the brilliancy of the fields of tulips in bloom: "Moreover it is admirable, but enough to drive the poor painter mad; it cannot be conveyed with our poor colours."[9]

∧
*Champ de tulipes en Hollande
(Tulip field in Holland)*
1886

Oil on canvas
54 × 81 cm
Michel Monet Bequest, 1966
Inv. 5173

>
*Vallée de Sasso. Effet de soleil
(Valley of Sasso. Sunlight effect)*
1884

Oil on canvas
65 × 81 cm
Michel Monet Bequest, 1966
Inv. 5009

Dazzling sights at Bordighera

It was in the company of Auguste Renoir that Monet set out for the French Riviera in December 1883. Crossing the frontier into Italy, they were both enchanted by Bordighera, a little old town in western Liguria. Monet went back there alone a month later, preferring solitude to work at full tilt. "I'm staying in a fairy-tale country," he enthusiastically told Théodore Duret. "I don't know which way to turn, everything is superb and I'd like to do everything; so I'm using up and spoiling lots of colours, because there are trials to be made. This

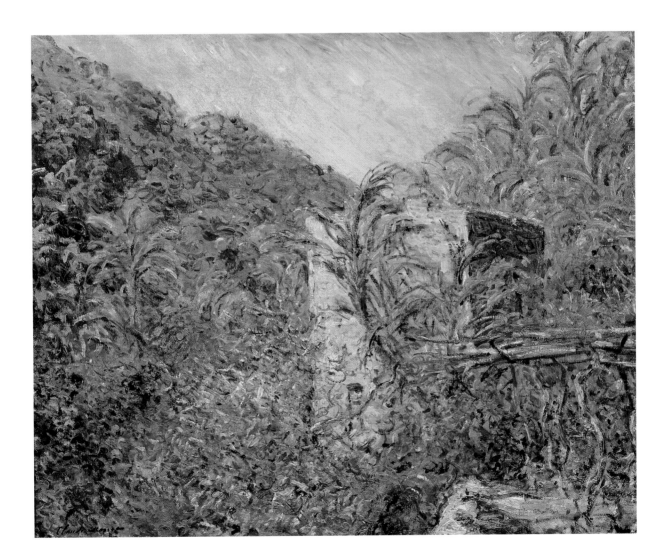

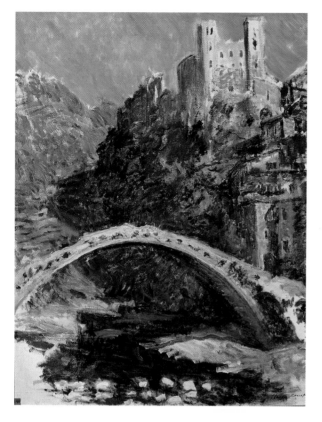

country is a completely new study for me and I'm only beginning to get my bearings and know where I'm going, what I can do. It's dreadfully difficult, you'd need a palette of diamonds and precious stones."[10]

In this valley of Sasso, Monet described several aspects of a large square villa buried beneath exotic, exuberant vegetation. He sent Alice "two photographs of the area I went to see yesterday, Dolce Acqua, in the Nervia valley, they're not well taken and only give an imperfect idea of the place, which is superb, but even so you'll find them interesting; there's a bridge that is a treasure of lightness."[11] That bridge spanning the torrent linked the *Château de Dolceacqua* (Dolceacqua castle) which belonged to the Doria family to the village. From these Italian lands Monet brought back canvases that were as dazzling as the painter intended, to the disdain of his detractors: "It is precisely that marvellous side I so much want to convey. Obviously lots of people will complain about improbabilty, madness, but too bad, they say the same when I paint our own climate. Coming here I had to bring back the arresting side."[12]

The Creuse

The poet Maurice Rollinat[13] invited many artists to his Fresselines region in Creuse. Gustave Geffroy, an art critic, writer and long-standing friend of the author of *Névroses,* took Monet along with him in 1889. Monet got down to work. "As you see," he wrote to Berthe Morisot, "here I am again in the back of beyond and getting to grips with the difficulties of a new part of the country. It's superb here, with a terrible wildness that reminds me of Belle-Île. (…) I've been so bowled over that I've been here for a good month."[14] But dependent on sudden changes in the weather and the extremely rapid metamorphoses of nature, Monet, as often on his

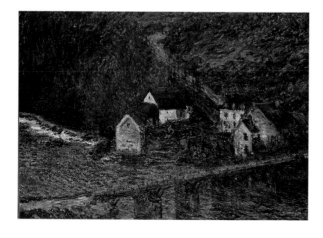

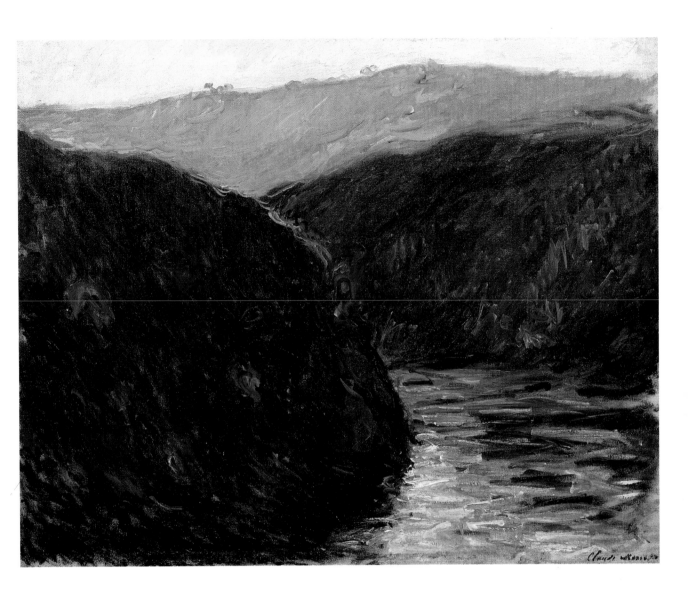

< ∧
Le Château de Dolceacqua
(Dolceacqua castle)
1884

Oil on canvas
92 × 73 cm
Michel Monet Bequest, 1966
Inv. 5012

<
Le Pont de Vervy
(Vervy bridge)
1889

Oil on canvas
65 × 92 cm
Michel Monet Bequest, 1966
Inv. 5026

∧
Vallée de la Creuse. Effet du Soir
(Creuse valley. Evening effect)
1889

Oil on canvas
65 × 81 cm
Michel Monet Bequest, 1966
Inv. 5176

>
Armand Guillaumin
(1841-1927)
La Creuse à Genetin
(The River Creuse at Genetin)
c. 1900

Oil on canvas
65 × 80 cm
Nelly Sergeant-Duhem Donation, 1985
Inv. 5264

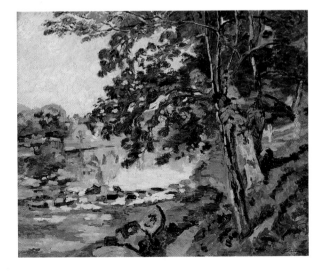

∧
Armand Guillaumin
(1841-1927)
*La Vallée de la Sédelle. Crozant
(The Sédelle valley. Crozant)*
c. 1898
Oil on canvas
Nelly Sergeant-Duhem Donation,
1985
Inv. 5265

>
*Le Mont Kolsaas en Norvège
(Mount Kolsaas in Norway)*
1895
Oil on canvas
65 × 100 cm
Michel Monet Bequest, 1966
Inv. 5100

∨
*Paysage de Norvège.
Les Maisons bleues
(Norwegian landscape.
Blue houses)*
1895
Oil on canvas
61 × 84 cm
Michel Monet Bequest
Inv. 5169

> ∨
*Norvège. Les Maisons rouges
à Björnegaard
(Norway. Red houses
at Björnegaard)*
1895
Oil on canvas
65 × 81 cm
Michel Monet Bequest, 1966
Inv. 5170

field trips painting from nature, went through periods of feeling discouraged: "In short, because of its transformations, I follow nature without being able to grasp it; and then this river which falls, rises again, green one day, then yellow, now dry, and tomorrow a torrent after the dreadful rain that is falling right now!"[15]

In spite of some sunlight effects, he exploits an often dark palette tinged with purple red to paint the heavy waters of the River Creuse flowing at the bottom of the ravine-like slopes. Years later, Guillaumin would in turn discover this valley and the village of Crozant. He was smitten by the region, and returned there frequently; and he saw spectacles blazing with colours.

Norway

Attracted by what he imagined Scandinavian landscapes would look like, and knowing the world of the playwright Henrik Ibsen, in February 1895 Monet visited his stepson Jacques Hoschedé, who was living in Norway. After travelling through Denmark and Sweden, he reached Christiania (Oslo), where he was surprised and flattered by his fame. He wanted to paint the winter and spent a long time looking for an original subject. At the invitation of the wife of the Norwegian writer Björnson, he stayed at Björnegaard, near Sandviken. The little village with coloured wooden houses delighted him because of "snow effects that are absolutely stupefying, that white immensity".

"I'm also doing a mountain," he wrote to Blanche, "which can be seen from everywhere here and makes me think of Fuji-Yama."[16] It was the first time that Monet had studied a mountain and for him Mount Kolsaas was evocative of Mount Fuji which he knew through the Japanese prints he collected. Thirteen pictures convey its imposing mass, with broad dark brushstrokes. Since his iterative treatment of the *meules* (haystacks), studied according to changes of light, Monet's approach has often been assimilated to that of Katsushika Hokusai, a correlation based also on the chromatic processes and the innovative options made in framing the scenes. This closeness is obvious in the series devoted to *Mont Kolsaas* (Mount Kolsaas) compared with the *Thirty-six views of Mount Fuji*.

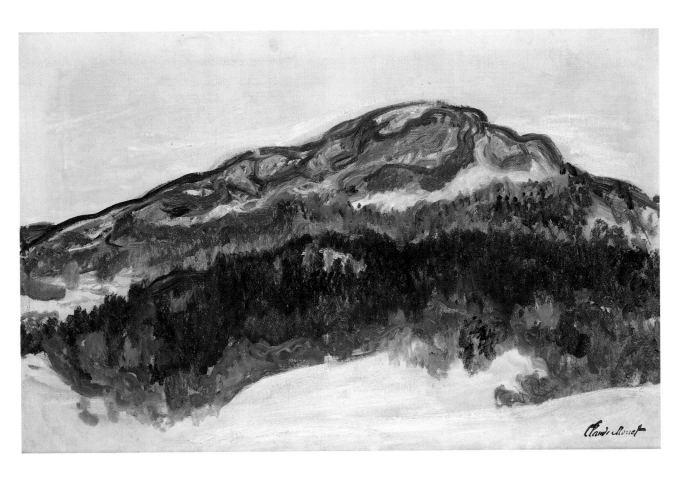

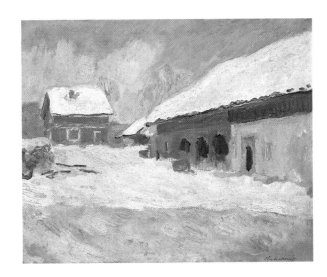

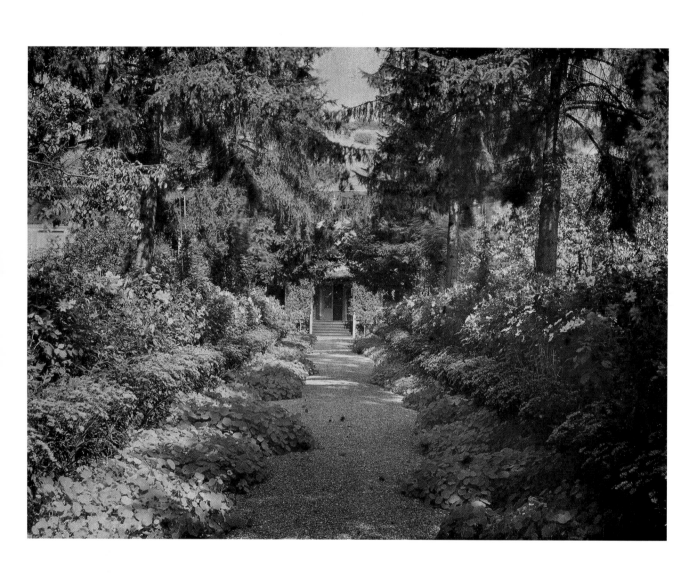

At Giverny

"Monsieur Monet, que l'hiver ni
L'été sa vision ne leurre,
Habite, en peignant, Giverny
Sis auprès de Vernon dans l'Eure."[1]

[Monsieur Monet, so that neither winter
Nor summer may trick his vision,
Lives, painting, at Giverny
Located near Vernon in the Eure.]

<
Giverny, the path with the spruce trees
Photograph on glass plate
MMM Archives

v
Monet on the path under the rose arches
Photograph
MMM Archives

"I'm perfectly ready to do whatever you like to get away from this horrible, ill-fated Poissy,"[2] **Monet wrote to his partner in life on 19 March 1882.** It was the time of his wanderings: he was at Pourville, had come back from Dieppe and would soon leave for Etretat. Monet could not get used to their latest address and often left home in search of inspiration. He was working eagerly and preparing a one-man show. It opened on 28 February 1883 at boulevard de la Madeleine in the Galerie Durand-Ruel. But it was "a catastrophe, a flop": the exhibition, "which is marvellous is bringing in nothing," Pissarro told his son Lucien. Added to this disappointment were the financial difficulties, embarrassments and obstacles of an irregular situation. Alice had chosen to follow the artist to Poissy in spite of being ordered by her husband Ernest Hoschedé to rejoin him in Paris. Monet was tired. After some time spent looking, he and Alice finally located the place that suited his creative desires. "I'm over the moon, Giverny is a splendid place for me,"[3] he wrote to his friend, the art critic Théodore Duret a month later, telling him about his find.

Contrary to legend which would like to see him as a hermit withdrawn into his family cocoon, Monet frequently

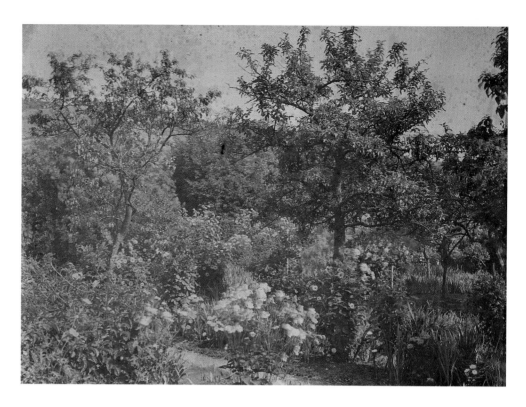

∧
View of the garden at Giverny
Photograph on glass plate
MMM Archives

>
Bras de Seine à Giverny
(Branch of the Seine at Giverny)
1885

Oil on canvas
65 × 92 cm
Michel Monet Bequest, 1966
Inv. 5175

∨
Giverny
Old post card
MMM Archives

entertained visitors, took an interest in literature and the theatre, cared about politics, often went to Paris and had no hesitation in setting off for more distant destinations, such as Norway or Venice. But Giverny became his constant home port. He was forty-three years old, and would spend the next forty-three years, till the evening of his life, in that small village. In the course of time he arranged his house, its dependencies, and planned his garden: there was the move, the building "of a shed to house my boats and store my easels and canvases. (…) Then I had the gardening which took some of my time (…) But now that is all finished, I'm not going to leave my paint-brushes any more."[4]

The first signs of success were about to become evident, and Monet would soon be free of money worries. But in 1890 he was still making appeals to his dealer Paul Durand-Ruel: "I'll be obliged to ask you for quite a bit of money, being on the point of buying the house I'm living in or leaving Giverny, which would upset me greatly, as I'm sure I would never again find such a set-up or such beautiful countryside."[5] After the house came the purchase of a plot of land on the other side of the road adjoining the bottom of the garden, and the creation and enlargement of a pond fed by a canal coming from

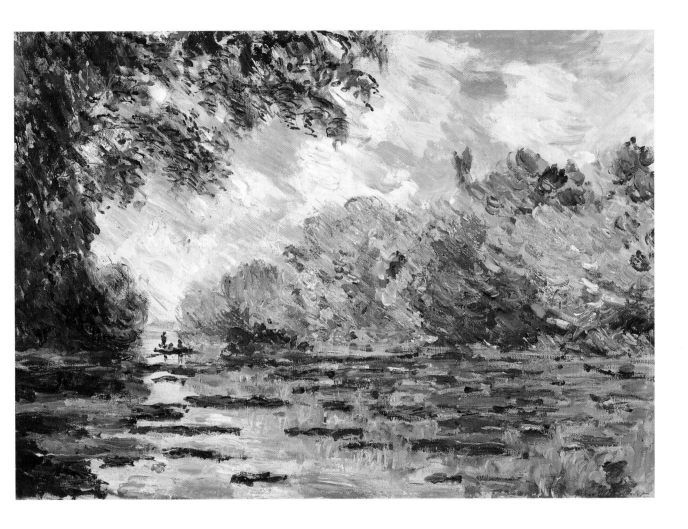

∧

Champ d'iris jaunes à Giverny
(Field of yellow irises at Giverny)
1887

Oil on canvas
45 × 100 cm
Michel Monet Bequest, 1966
Inv. 5172

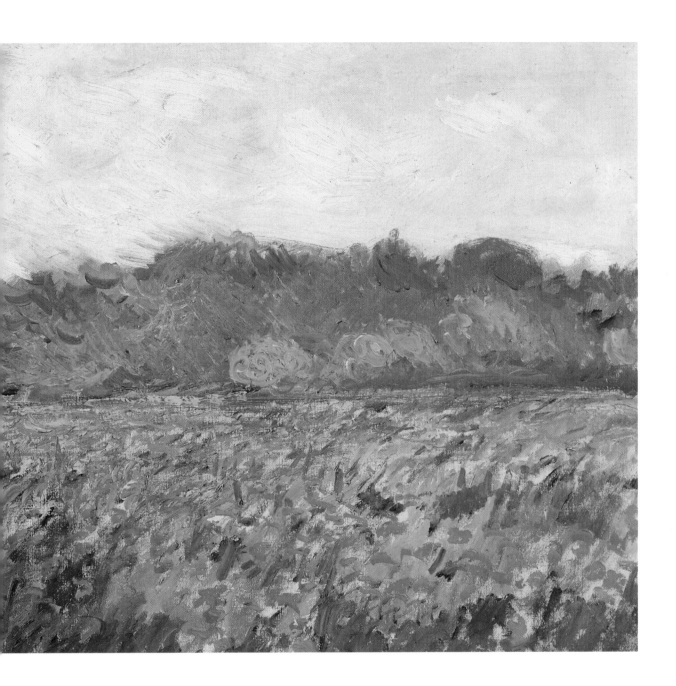

the River Epte. In 1914 there would be the building of the big studio with top lighting, equipped to handle large canvases, which would allow him to work under shelter with the maximum possible luminosity. Apart from the works associated which his few journeys, Monet henceforth drew his inspiration solely from Giverny. His territory, a garden he had imagined, created and perfected completely himself; his sole, but inexhaustible subject, constantly renewed by the light of the times of day and the seasons, and revealed by the colours of his palette.

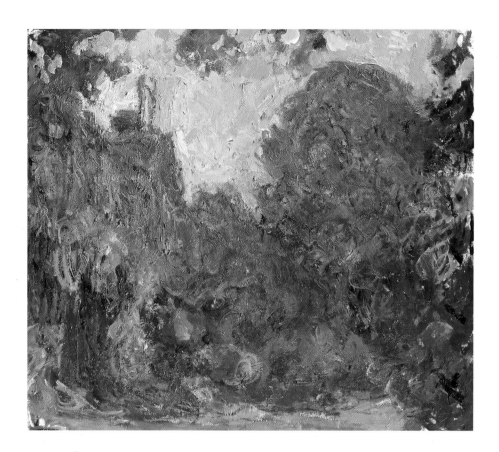

>

*La Maison vue du jardin
aux roses
(The house viewed
from the rose garden)*
c. 1922

Oil on canvas
81 × 92 cm
Michel Monet Bequest, 1966
Inv. 5086

V

*La Maison de l'artiste
vue du jardin aux roses
(The artist's house viewed
from the rose garden)*
c. 1922

Oil on canvas
89 × 92 cm
Michel Monet Bequest, 1966
Inv. 5108

> >

*La Maison vue du jardin
aux roses
(The house viewed
from the rose garden)*
c. 1922

Oil on canvas
81 × 93 cm
Michel Monet Bequest, 1966
Inv. 5087

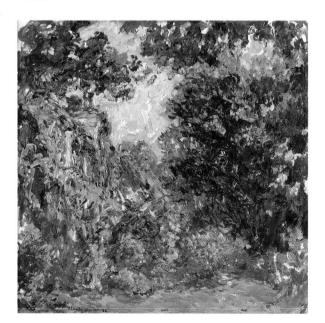

**Immediately he got there in June 1883, Monet
thought about beautifying the garden and sowed
the first seeds "so as to pick a few flowers to paint
when the weather is bad".[6] Even when he was not
there, he constantly made recommendations in
his letters for improving the paths and beds.** His wife
and his friends Octave Mirbeau and Tadamasa Hayashi
were involved in the plantings. Each period of bloom
was thought through like a picture in the making.
"You're not an artist if you don't carry your picture in
your head before you execute it."[7] Some time later,
helped by several gardeners, he distributed, planted and
pruned trees and flowers around the family home. He
designed his garden with passion according to species,
forms and combinations of colours, citing it as his "finest
masterpiece".

"The garden at Giverny comprises two worlds, the world
of flowers and the world of water. The world of flowers,
at the back of which stand the painter's residence and
studios, is wider than it is long, and comes down in a
slight slope towards the road that separates it from the

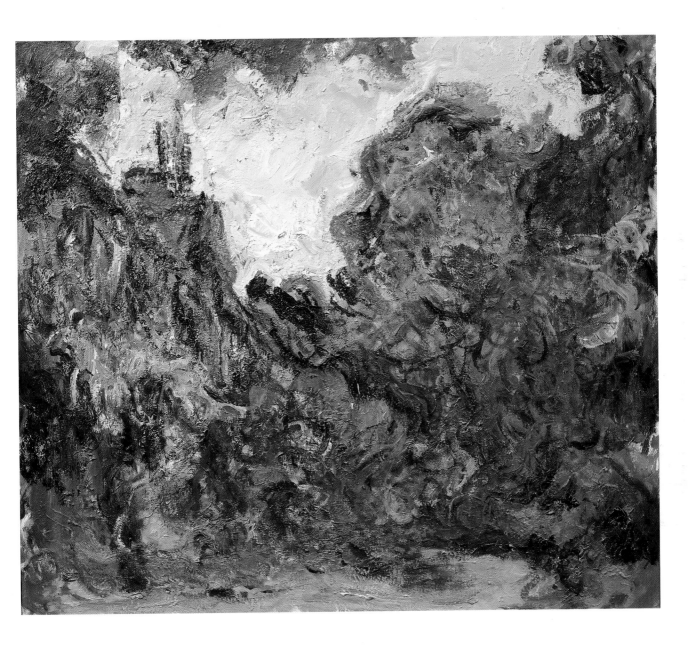

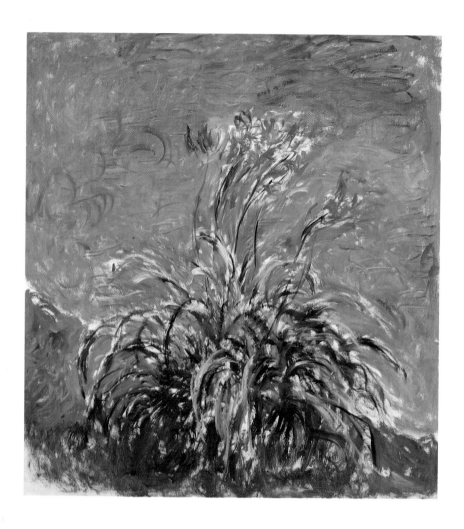

∧
Les Hémérocalles
(Day lilies)
c. 1914

Oil on canvas
150 × 140 cm
Michel Monet Bequest, 1966
Inv. 5097

>
Les Roses
(Roses)
1925

Oil on canvas
130 × 200 cm
Michel Monet Bequest, 1966
Inv. 5096

water. A large central path divides it into two main rect-angles intersected by narrow paths that barely allow you to pass between the clumps of flowers. They are planted profusely in associated or contrasted phalanxes, and truly form choirs that respond to one another, mix together, and balance out like those of the parts in a huge oratorio."[8]

Agapanthus, day lilies and irises formed the colourful, scented clumps. The writer Octave Mirbeau who shared Monet's enthusiasm for horticulture gives dazzling descriptions of the garden at all seasons, especially in the spring when "atop their pliable stems, the day lilies bow down their sweet-smelling calyces".[9]

But the painter was especially fond of irises. He planted them lining the paths, on the grass in his orchard and near the water-lily pond. Among the many varieties, his preference was for *Iris germanica;* they "raise their strange curving petals, decked in white, mauve, lilac,

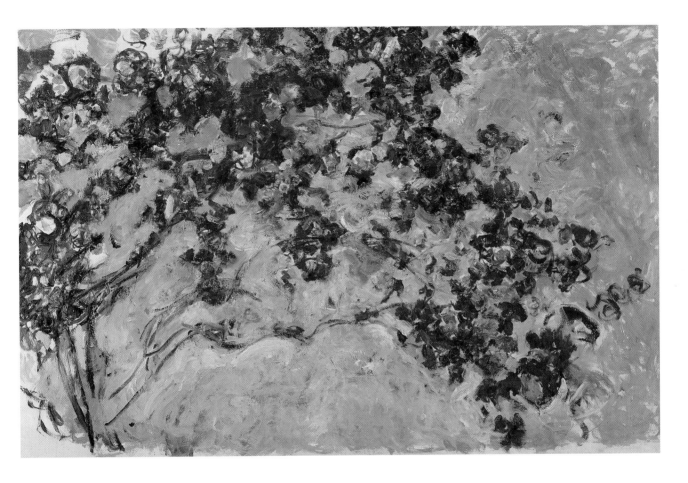

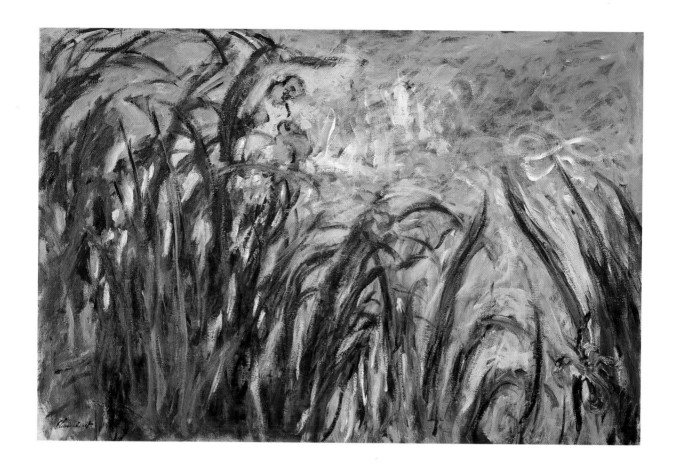

yellow and blue, striped with streaks of brown and purple flecks, their complicated under-parts evoking mysterious analogies, tempting, perverse dreams, similar to those that float around disturbing orchids".[10]

Monet's existence seemed to keep pace with his painting in an almost magical setting and the atmosphere "full of life and youth" of a united family. His work reflected his passion for nature, almost an obsession, an imperious need to enter into dialogue with colours, to express their fleeting variations, in a total freedom of spirit. The only impediments he felt were constant callings into question, real doubts, regarding the quality of his work. Often disheartened, sometimes furious with the result, he went as far as to destroy his works, whereas the terror of war and the times of privation and sorrow seem not to have been an obstacle to his creative genius.

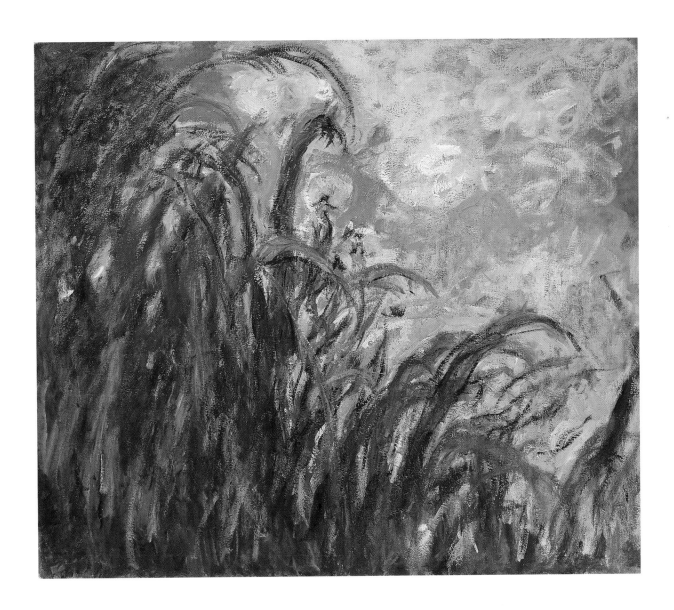

< ∧
Iris jaunes et mauves
(Yellow and purple irises)
c. 1924

Oil on canvas
106 × 155 cm
Michel Monet Bequest, 1966
Inv. 5083

< ∨
Iris
(Irises)
c. 1924

Oil on canvas
105 × 73 cm
Michel Monet Bequest, 1966
Inv. 5076

∧
Les Iris jaunes
(Yellow irises)
c. 1924

Oil on canvas
130 × 152 cm
Michel Monet Bequest, 1966
Inv. 5095

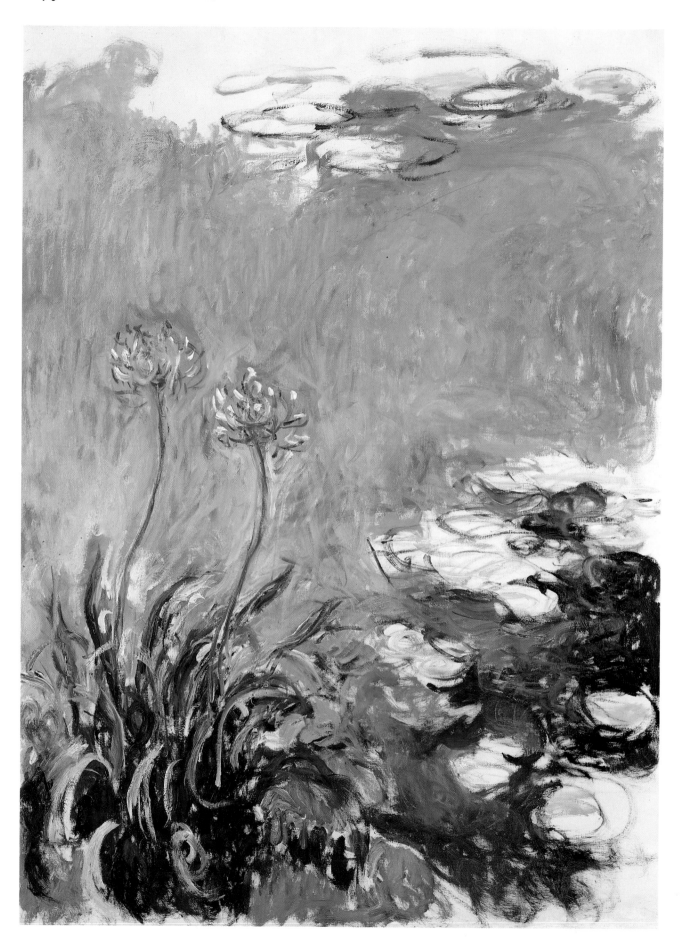

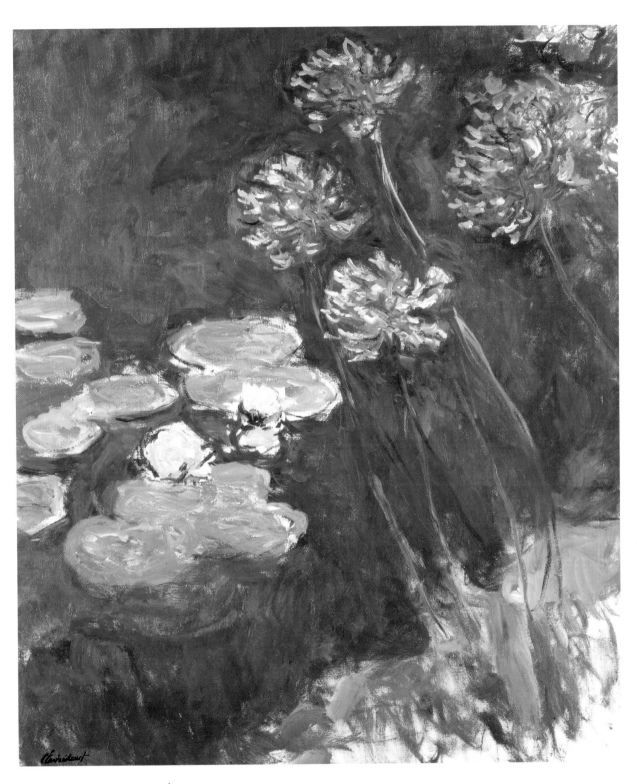

<
Les Agapanthes
(Agapanthus)
c. 1914

Oil on canvas
200 × 150 cm
Michel Monet Bequest, 1966
Inv. 5121

∧
Nymphéas et agapanthes
(Water lilies and agapanthus)
c. 1914

Oil on canvas
140 × 120 cm
Michel Monet Bequest, 1966
Inv. 5084

<
Sacha Guitry
(1885-1957)
Claude Monet

Photograph
MMM Archives

V
Alice Monet

Photograph
MMM Archives

>
L'Allée des rosiers
(The path under the rose arches)
c. 1920

Oil on canvas
81 × 100 cm
Michel Monet Bequest, 1966
Inv. 5090

By 1909 Alice felt the first effects of an illness that led to her death on 19 May 1911. Monet was "distraught, lost"[11]. In spite of the support of the children, he was overcome by sadness and loneliness. For a time he gave up painting, only returning to his paint-brushes six months later when he took his house as a subject.

On 9 February 1914 his elder son Jean, who had married Blanche Hoschedé, suffered a fatal stroke, and from then on his widow was to live at the artist's side. Monet's daughter-in-law became his "blue angel", a name given to her by Clemenceau.

Little by little the painter regained the will to work, then his enthusiasm. But war broke out and his son Michel volunteered to go to the front while Jean-Pierre Hoschedé was mobilised. Monet stayed. "Too many memories keep me here where half my life has been spent, and when it comes down to it I'd rather die here amidst my works than escape and leave everything that was my life to thieves or the enemy."[12]

In addition to the fragility of old age, Monet was obsessed by the threat of blindness. Eye trouble had started many years earlier. As early as 1912, the doctor diagnosed a cataract in his right eye and a disease in the other eye. His apprehension led him to keep delaying any operation: "The operation is nothing, but my sight after it would be completely changed, which is crucial for me."[13] It took place in 1916. There were three successive

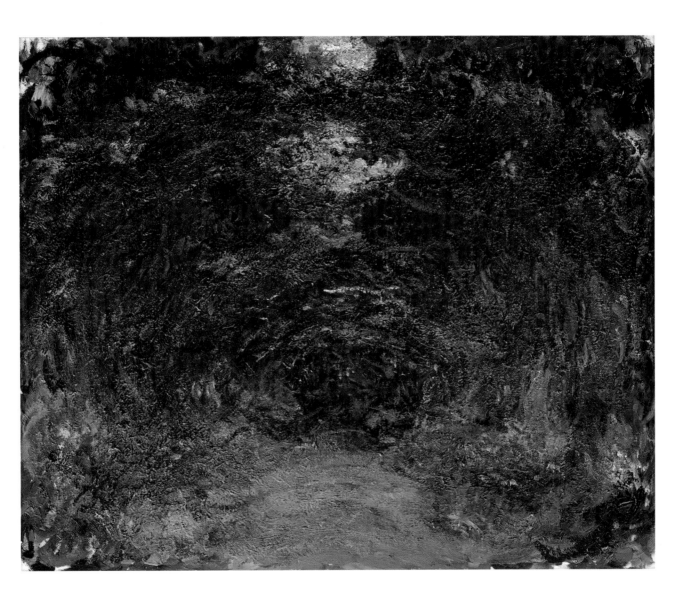

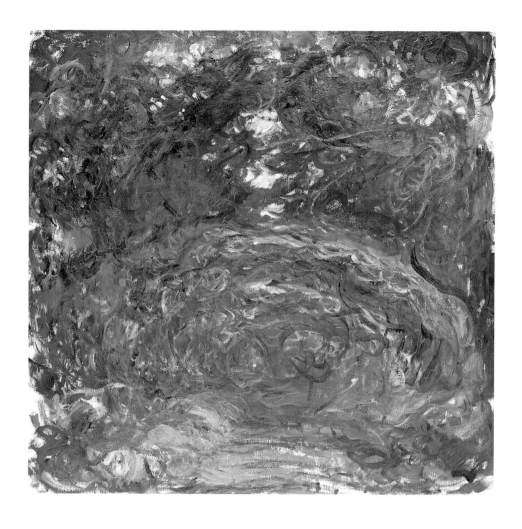

∧

L'Allée des rosiers
(The path under the rose arches)
c. 1920

Oil on canvas
90 × 92 cm
Michel Monet Bequest, 1966
Inv. 5088

>

L'Allée des rosiers
(The path under the rose arches)
c. 1920

Oil on canvas
92 × 89 cm
Michel Monet Bequest, 1966
Inv. 5104

operations on his right eye, and the surgeon was satisfied with the result.

After much suffering and worry about his eyesight which he recovered only partially, Monet regained some hope: "I can read better and better, but that's over and done with; seeing from a distance and finding my way is another matter, which will come with time; as for colours, it's increasingly disconcerting, but I'm not losing heart,"[14] he wrote to Clemenceau in September 1923. A year later, still dissatisfied with his perception of colours, he was awaiting the arrival of new promised lenses to correct the appearance of yellow that veiled the hues. In March 1925 he lamented again: "Painters who have had a cataract operation have to give up painting: and that is what I haven't managed to do."[15] Several times Monet depicted the front of his house covered with Virginia creeper and clematis plants, viewed from the rose garden or the central path. This series

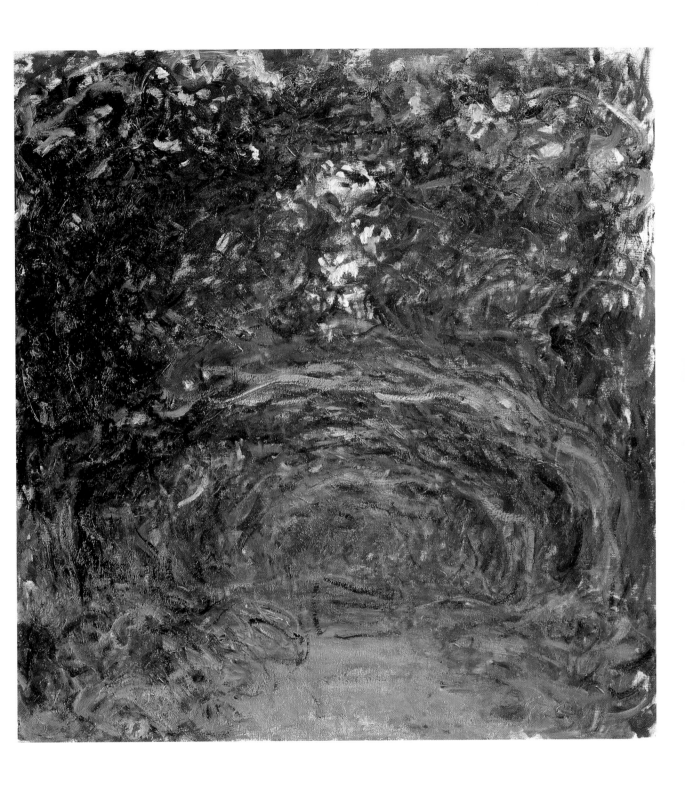

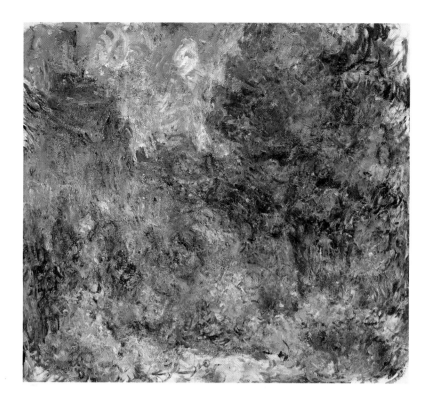

demonstrates the inaccurate perception of colours caused by the eye complaint he was suffering from. After the operation on his right eye, xanthopsia (yellow vision) then cyanopsia (purple-blue vision) influenced his palette.

"The central path is covered by the green and floral vault formed by the trellised arches of climbing roses, and on either side the continuous, wide, bushy border is formed by creeping nasturtiums which, left free to wander, form unruly yet rhythmic festoons."[16]

∧
*La Maison de Giverny
vue du jardin aux roses
(The house at Giverny viewed
from the rose garden)*
c. 1922

Oil on canvas
89 × 100 cm
Michel Monet Bequest, 1966
Inv. 5103

>
*Nymphéas. Effet du soir
(Water lilies. Evening effect)*
c. 1897

Oil on canvas
73 × 100 cm
Michel Monet Bequest, 1966
Inv. 5167

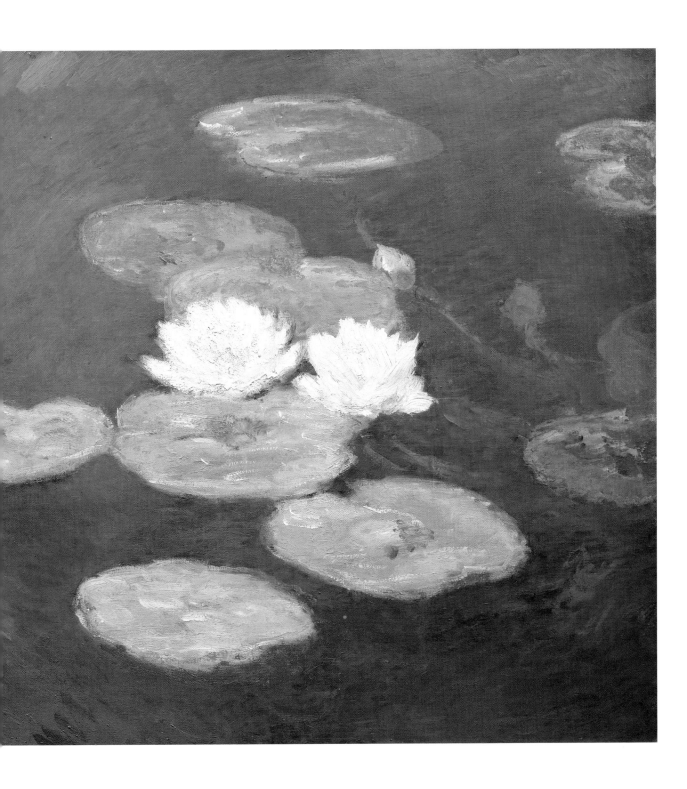

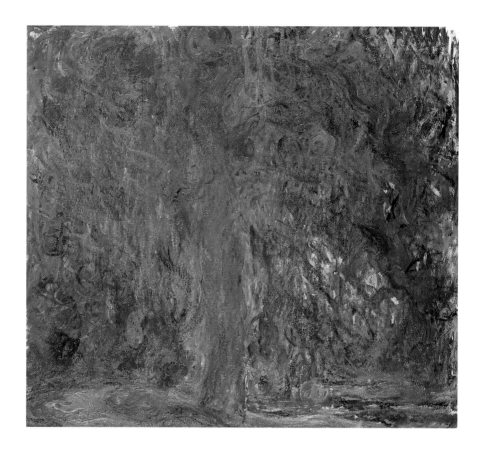

>
Saule pleureur
(Weeping willow)
c. 1918

Oil on canvas
100 × 110 cm
Michel Monet Bequest, 1966
Inv. 5078

∨
View of the water-lily pond
Photograph on glass plate
MMM Archives

> >
Le Saule pleureur
et Bassin aux nymphéas
(Weeping willow
and water-lily pond)
c. 1916

Oil on canvas
200 × 180 cm
Michel Monet Bequest, 1966
Inv. 5125

Following double page
Le Pont japonais
(The Japanese bridge)
1918

Oil on canvas
100 × 200 cm
Michel Monet Bequest, 1966
Inv. 5077

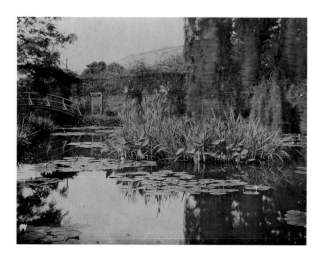

It was in 1893 that Monet bought a plot of land at the end of his property, on the other side of the railway track. He laid out his water garden there, by diverting the course of the Epte, a tributary of the Seine. In 1901 he bought another piece of land to enlarge his pond, where for years he went to admire and draw inspiration from all the mysterious manifestations and appearances of nature.

At the west end of the pond he built a bridge, after obtaining permission from the prefect in July 1893. It conjures up the elegance of the "Monkey Bridge in Kai Province" by Utagawa Hiroshige.

The bridge which stands above the pond is in fact a reminder of Monet's fascination with Japan. Attracted by the work of Japanese artists and their prints, the treatment of which reflects some of his own artistic preoccupations and pictorial tastes, Monet built up a very fine collection of more than 200 prints which cover the walls of his house. The most perceptible affinity between Monet and the ukiyo-e printmakers is certainly their shared love of flowers and landscape.

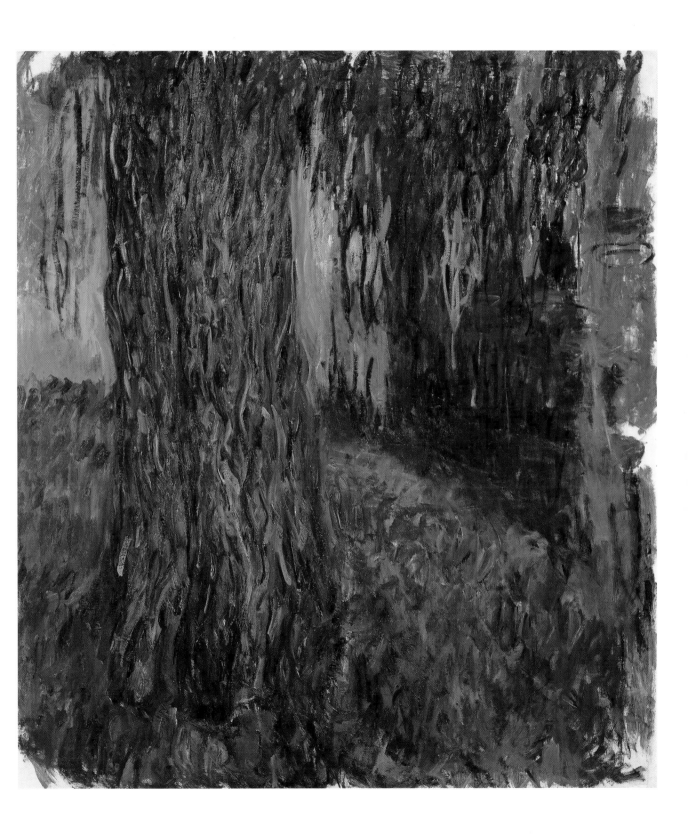

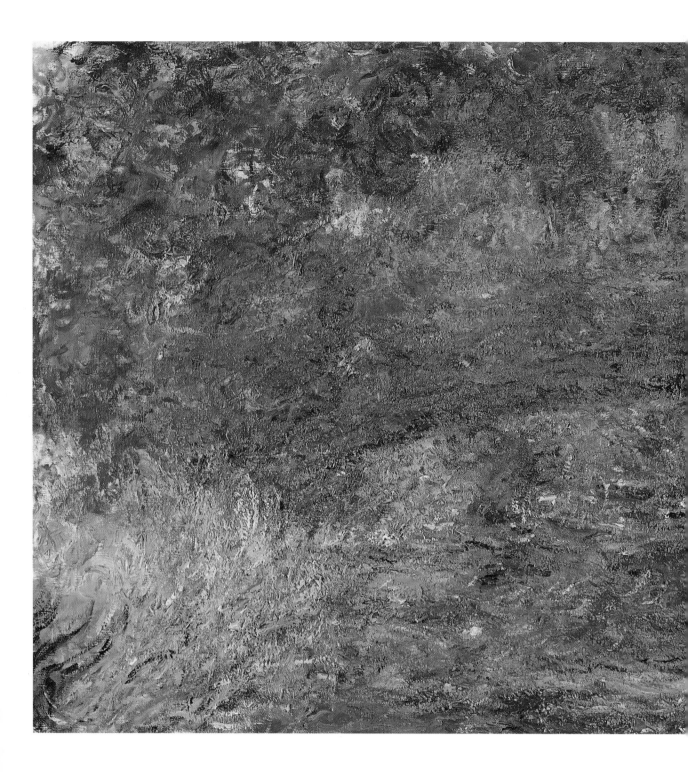

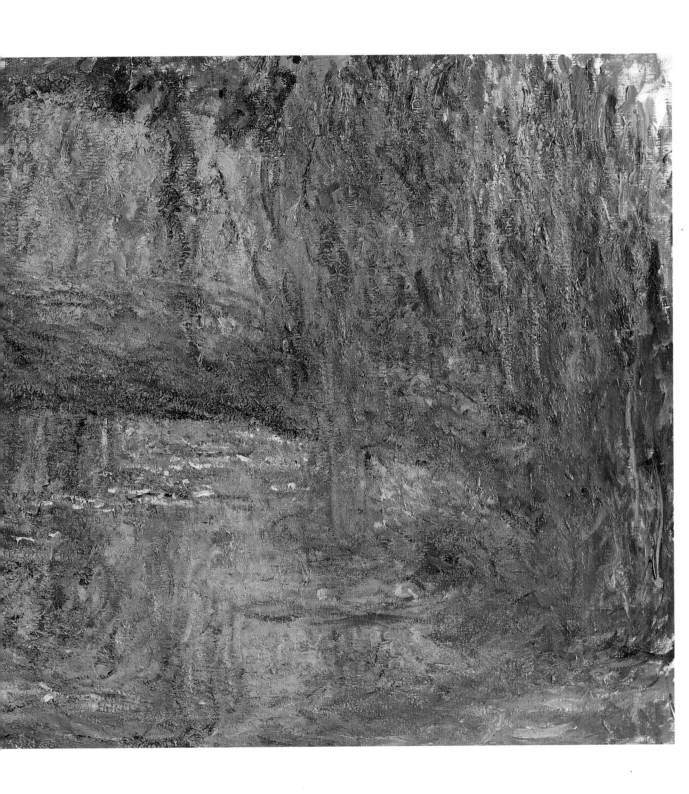

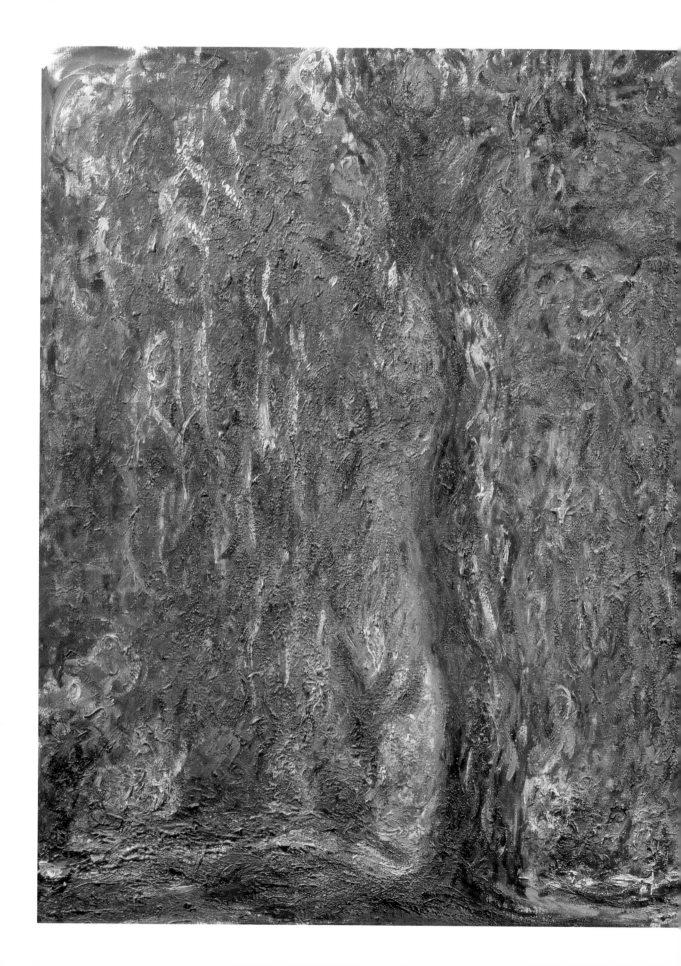

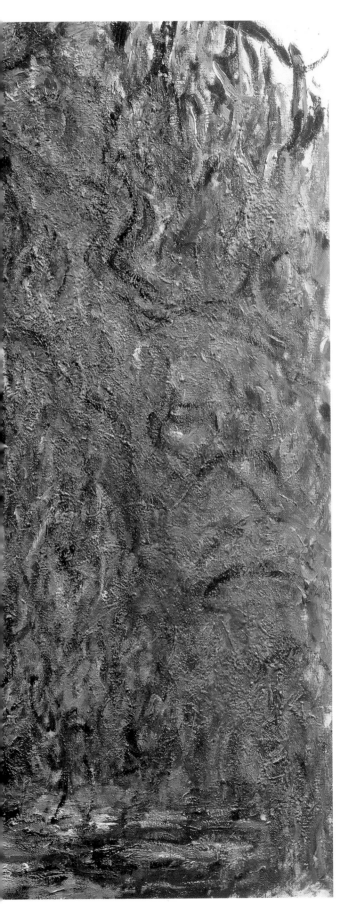

<
Saule pleureur
(Weeping willow)
c. 1918

Oil on canvas
100 × 120 cm
Michel Monet Bequest, 1966
Inv. 5080

Following double page
Glycines
(Wisteria)
c. 1919

Oil on canvas
100 × 300 cm
Michel Monet Bequest, 1966
Inv. 5123

Glycines
(Wisteria)
c. 1920

Oil on canvas
100 × 300 cm
Michel Monet Bequest, 1966
Inv. 5124

The first picture Monet made of the bridge is a winter scene[17], painted in 1895. Between 1899 and 1900, he returned to his motif in a still realistic series in which the arch of the bridge, its structure clearly defined, occupies all the space. In the different versions held by the Musée Marmottan, the footbridge is now only suggested by fragmented, flamboyant touches. They form horizontal lines bent under the weight of the luxuriant vegetation which invades the canvas. The first stage of a reduction of the visual field which would become more and more marked, eventually only embracing the actual plane of the water.

This group constitutes a series of easel pictures conceived for themselves outside any pictural programme. They date from 1918 to 1924, without any further chronological precision, as there is nothing to demonstrate adequately and with certainty the influence on some pictures rather than on others of Monet's cataract, or that of the various lenses in the glasses worn by the artist.

On the Japanese bridge Monet had an arch built where "wisteria plants climb (with flowers which) hang down in bunches, in multicoloured stalactites, the tips coming to meet their reversed reflected image in the Epte, as in caves the petrifactions rising from the ground taper up towards those descending from the ceiling".[18] He devoted several canvases to this motif, some of which were intended for the pavilion in the garden of the Hôtel Biron which then belonged to the Duc de Trévise. This project was abandoned in 1921. The two completely finished *Glycines* (Wisteria) friezes held by the Musée Marmottan were part of that commission.

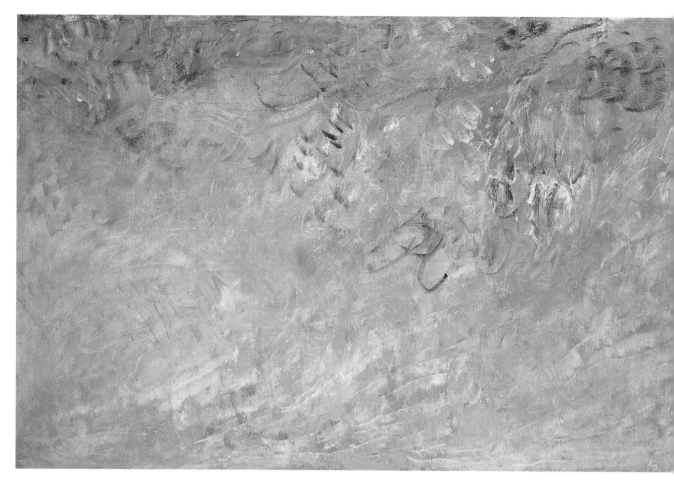

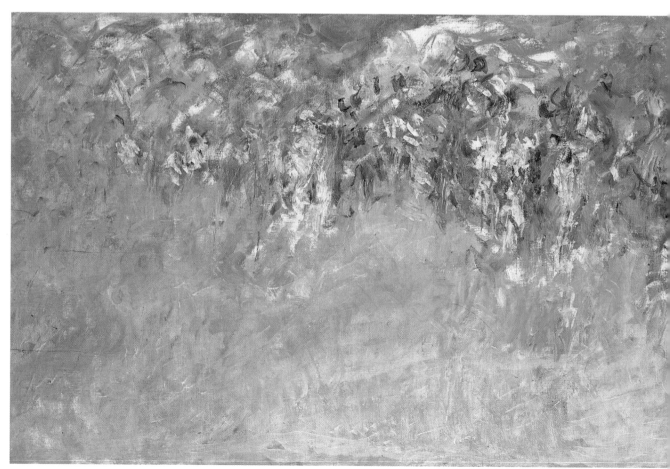

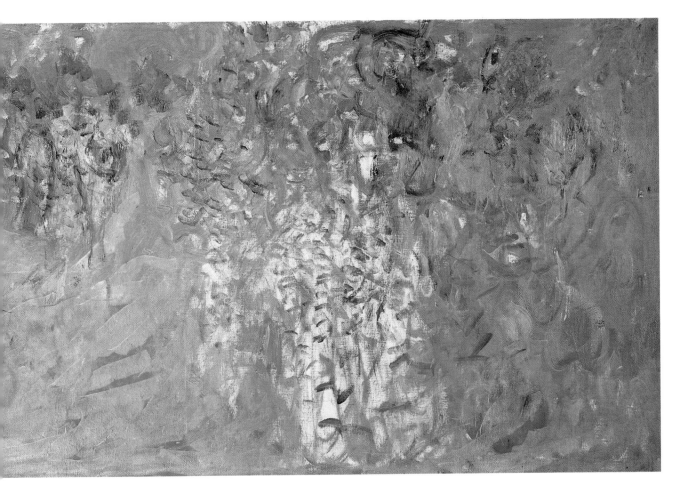

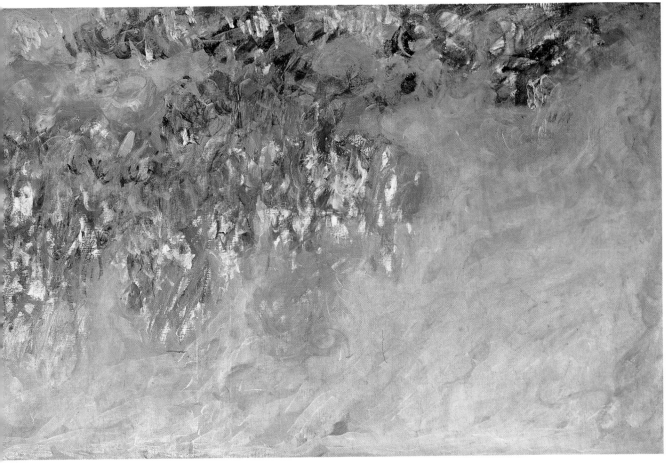

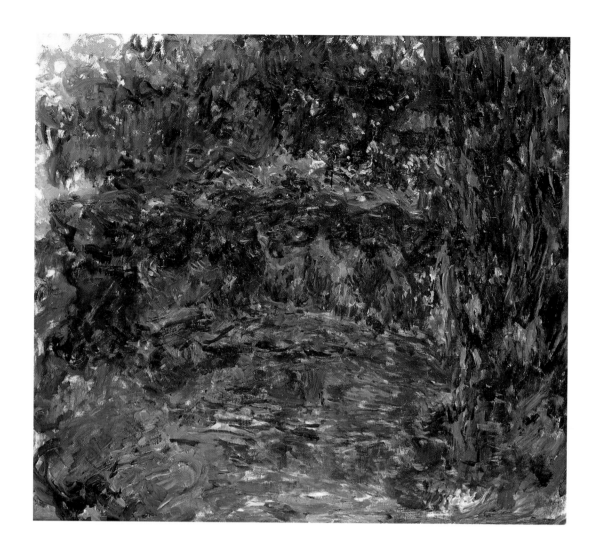

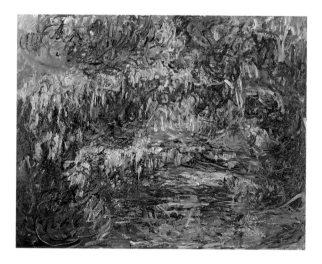

"He loves water as he would a lover"[19]

Monet explored his landscapes of water and reflections untiringly throughout the final years of his life. He painted the pond with aquatic plants floating on it, and bursts of sunlight, thick clouds shading the sky, and foliage stirring at the breath of the breeze reflected in it. "My life," Monet observed at the age of seventy-eight, "is spent thinking only of what I am doing, my confounded painting. When evening comes I ponder and think only of what I have done in the day, looking forward to the next day, with the hope of doing better. And the days, weeks, months go by like that, not moving from here."[20]

Several weeping willows are embedded on the bank. Their branches fall languorously over the water of the pond, and serve as a subject. Some versions concentrate on the tree with its trunk dividing the composition; the

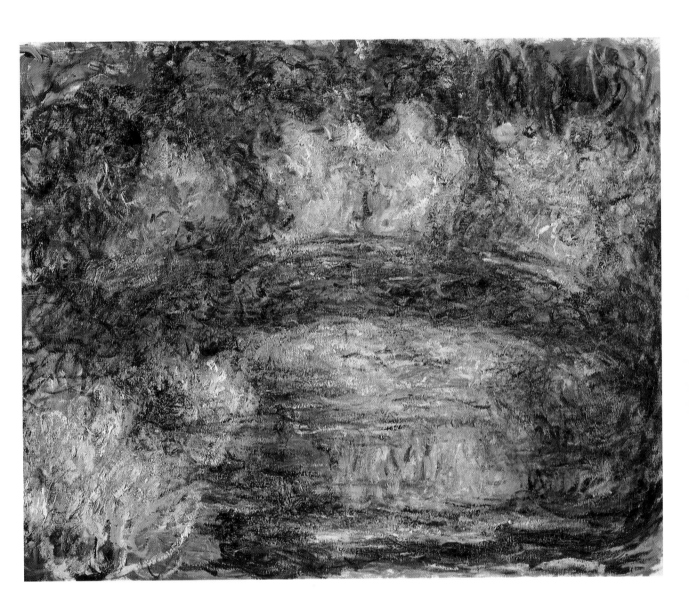

< ∧
Le Pont japonais
(The Japanese bridge)
c. 1918

Oil on canvas
89 × 100 cm
Michel Monet Bequest, 1966
Inv. 5091

<
Le Pont japonais
(The Japanese bridge)
c. 1918

Oil on canvas
89 × 116 cm
Michel Monet Bequest, 1966
Inv. 5106

∧
Le Pont japonais
(The Japanese bridge)
c. 1918

Oil on canvas
74 × 92 cm
Michel Monet Bequest, 1966
Inv. 5177

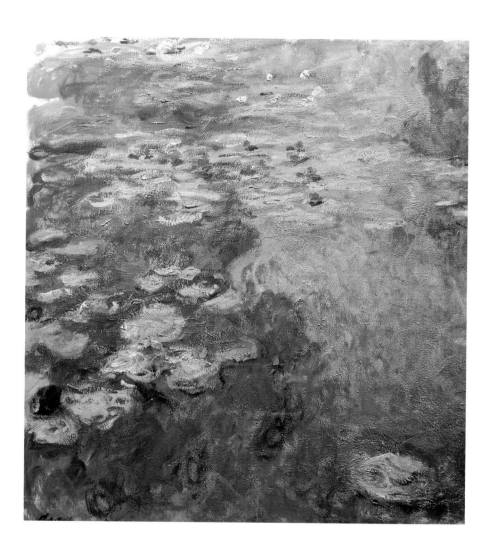

∧
Le Bassin aux nymphéas
(The water-lily pond)
c. 1917

Oil on canvas
130 × 120 cm
Michel Monet Bequest, 1966
Inv. 5165

>
La Barque
(The boat)
1887

Oil on canvas
146 × 133 cm
Michel Monet Bequest, 1966
Inv. 5082

barely suggested framework of branches is bending under the abundant greenery that covers the canvas in its entirety. Others are interested only in the trunk, alone, robust and masterly, planted in the foreground to fill one half of the canvas, framing the view in an original way. And the painter untangles the branches, offering a play of airy brushstrokes, when they overhang the water muddied by their shadow or the greyness of the weather. Here Monet sketches only a leafy curtain reflected on the waters that encircle a few water lilies.

"Here is the surface of the water, calm, motionless, rigid and deep, the plane established by the flat leaves of the water lilies. On this water the buds and flowers are placed, open, burst forth, and close again. Above, the sky with its wandering clouds, the branches of trees swaying, mingling with the aquatic plants that are constantly tied together and untied by the peaceful current.

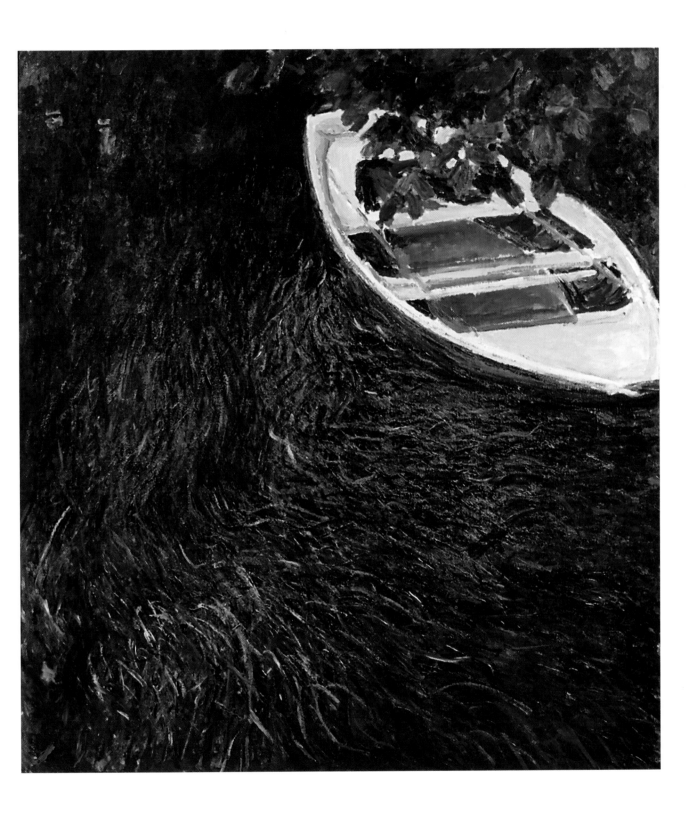

>
Nymphéas
(Water lilies)
1903

Oil on canvas
73 × 92 cm
Michel Monet Bequest, 1966
Inv. 5163

∨
Nymphéas
(Water lilies)
1903

Oil on canvas
89 × 100 cm
Michel Monet Bequest, 1966
Inv. 5166

I am deliberately pointing out this illusion of movement Monet gives us here with the reality of the light. Everything is moving and everything is living in these admirable works, and yet they all have the magnificent calm of art, that plenitude, that serenity which only exceptional works possess."[21]

This is the wonder of the water lilies: a first show of them was held in Paris, then in America, in 1900. Nine years later forty-eight works were again exhibited at Durand-Ruel's under the title chosen by Monet, *Les Nymphéas, paysages d'eau* (Water lilies, water landscapes), and scored a great public success.

From 1897 until his death in 1926, Monet unremittingly painted this broad-leaved plant. "These landscapes of water and reflections have become an obsession. It is beyond my strength as an old man, yet I want to succeed in conveying what I feel."[22] More than 200 pictures

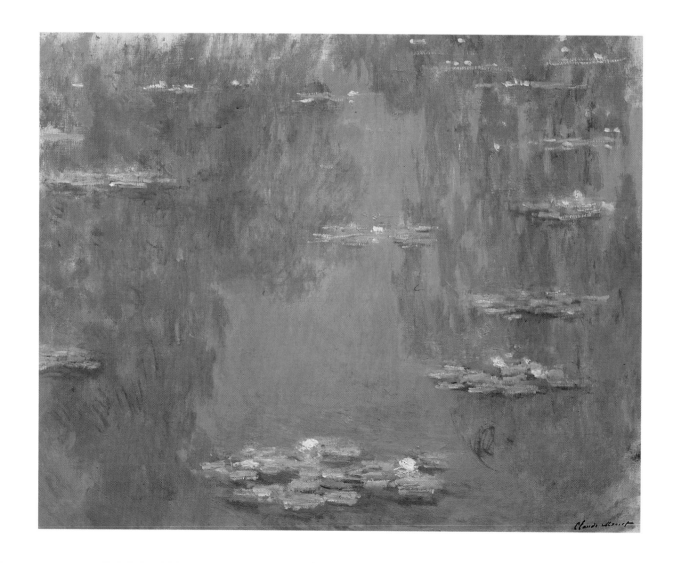

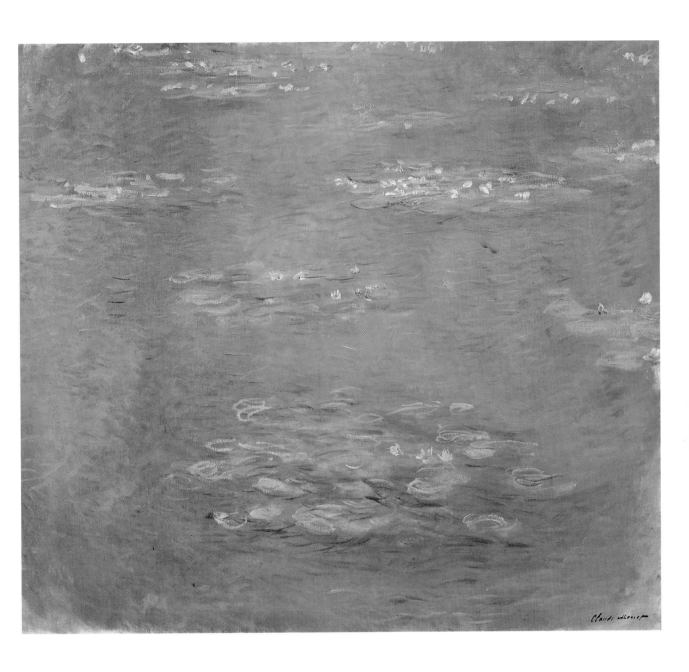

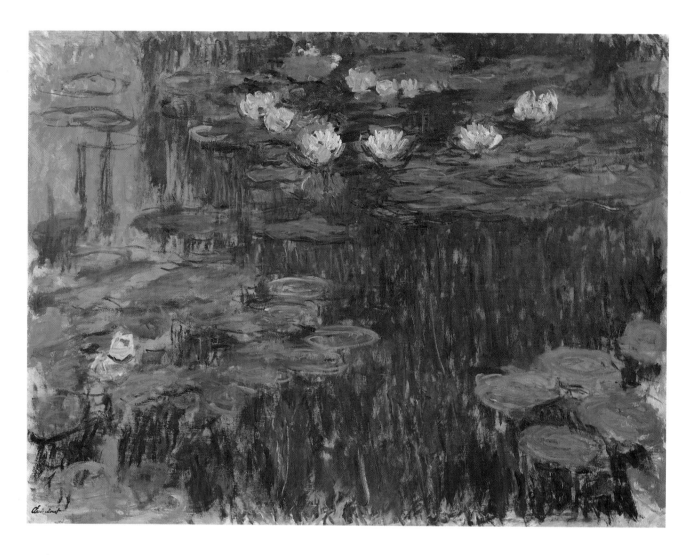

∧
Nymphéas
(Water lilies)
c. 1914

Oil on canvas
150 × 200 cm
Michel Monet Bequest, 1966
Inv. 5116

>
Nymphéas
(Water lilies)
c. 1916

Oil on canvas
200 × 180 cm
Michel Monet Bequest, 1966
Inv. 5119

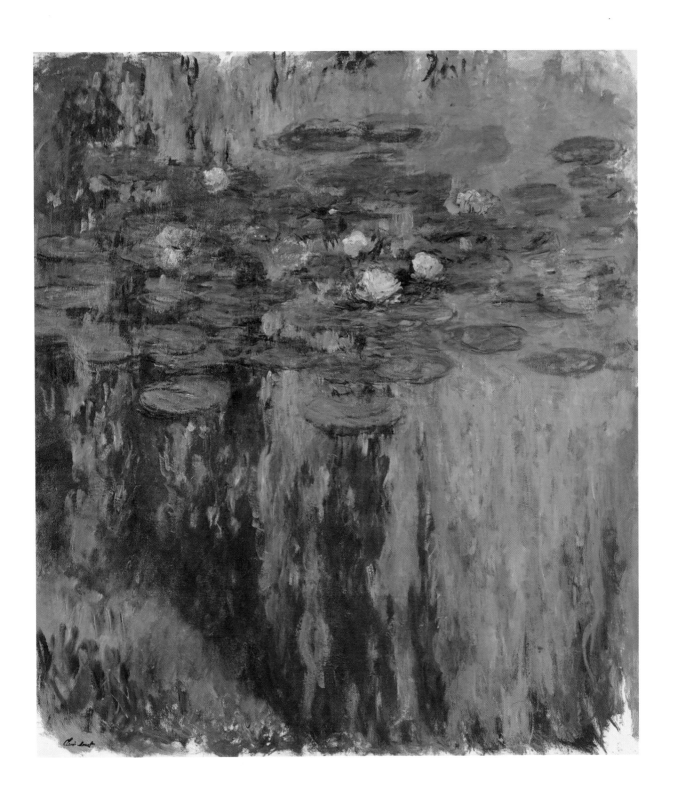

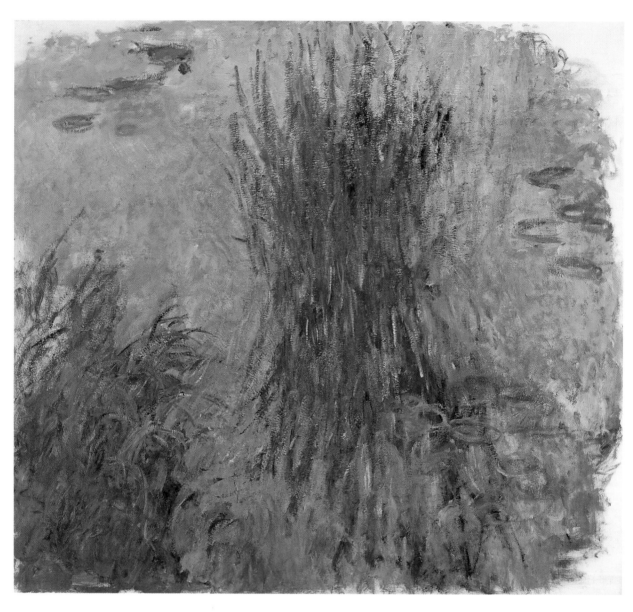

∧
Nymphéas
(Water lilies)
1914

Oil on canvas
180 × 200 cm
Michel Monet Bequest, 1966
Inv. 5120

>
Nymphéas
(Water lilies)
c. 1914

Oil on canvas
130 × 150 cm
Michel Monet Bequest, 1966
Inv. 5085

are devoted to water lilies, a gigantic series. The pond on its own covers the field of the canvas, there is no longer a horizon line, the planes merge, perspective is forgotten, the sky exists only through its reflection in the water. Monet pursued his attempt to pinpoint the ephemeral appearance of things, their metamorphosis up to the point of deliquescence.

Monet never ceased to want to transcribe with his brush his perception of light, its vibrations on natural elements, its reflections on water or on the noble stone of cathedrals.

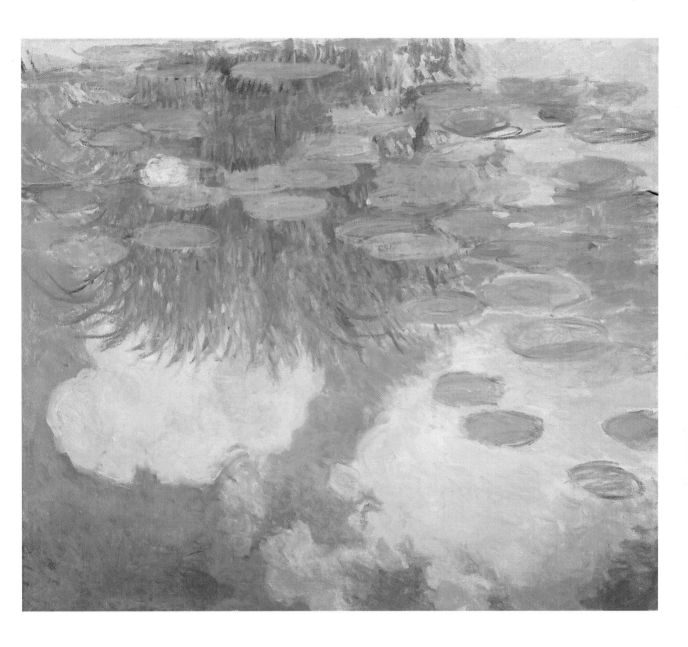

"Flowers of the earth, yet also flowers of the water,
these tender water lilies which the Master has depicted
in sublime paintings including this garden (more a true
transposition of art than a model for pictures, a picture
already executed at the level of nature which lights up
beneath the gaze of a great painter) are like a first,
living sketch; at the very least the palette on which
the harmonious shades are prepared is already made,
and delightful."

Marcel Proust

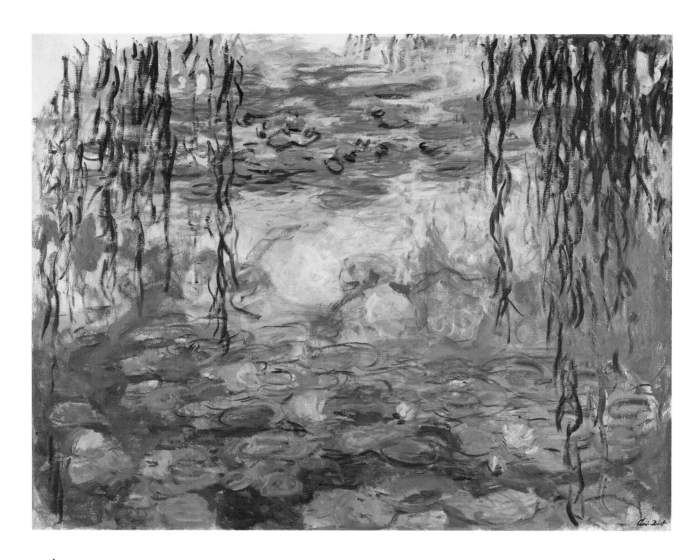

∧
Nymphéas
(Water lilies)
c. 1916

Oil on canvas
150 × 197 cm
Michel Monet Bequest, 1966
Inv. 5164

>
Nymphéas
(Water lilies)
c. 1916

Oil on canvas
200 × 180 cm
Michel Monet Bequest, 1966
Inv. 5117

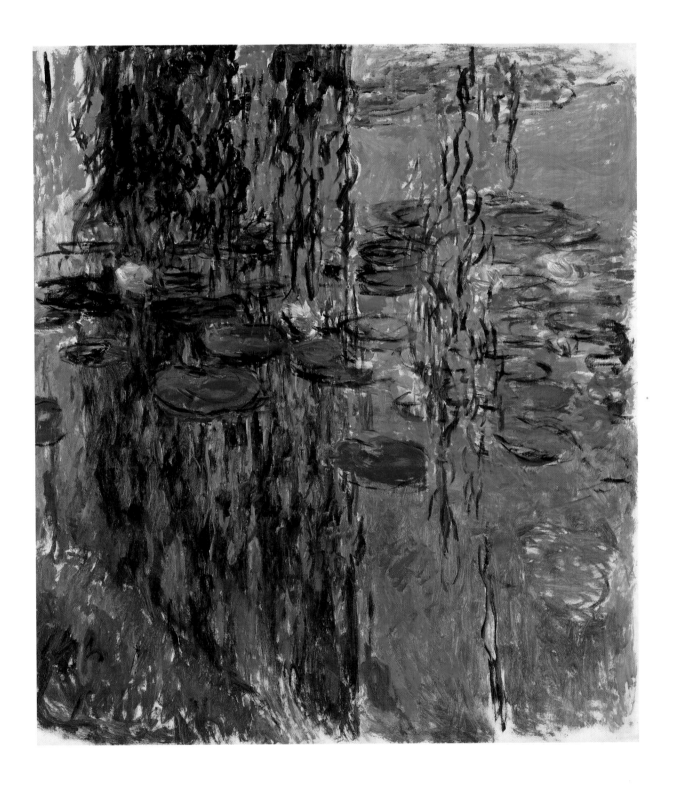

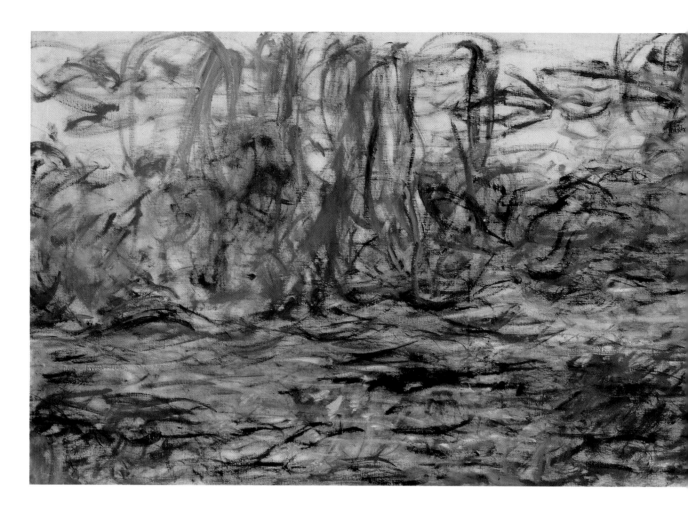

He "made emerge from his palette all the fires and all the decompositions of light, all the plays of shadow, all the magical effects of the moon and all the ways things vanish in the mist."[23] At the end of his life, in spite of the hazards of old age, his genius was at its height. He offers us unknown splendours with all the simplicity and sincerity of a man who only wanted to reproduce what he saw.

On 17 May 1927 the public saw the *Grandes Décorations* (Giant Decorations) for the first time. It was after the Armistice in 1918 that Monet had decided to make a gift of two panels of water lilies to the State. "It is the only way I have of taking part in the victory,"[24] he explained to his dear, great friend Georges Clemenceau, who would urge him to make a gift of a bigger group of his large-scale compositions. At the end of his life the statesman came to visit him as a neighbour from his house in Benouville. Full of praise for him, always attentive and always there, he was unstinting in his encouragement

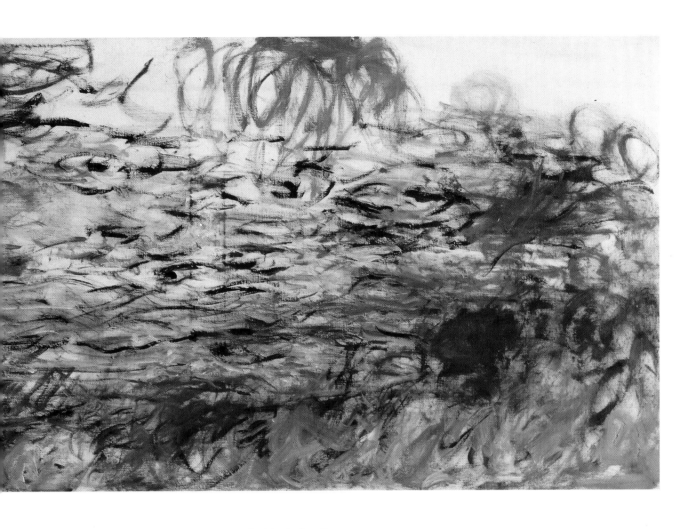

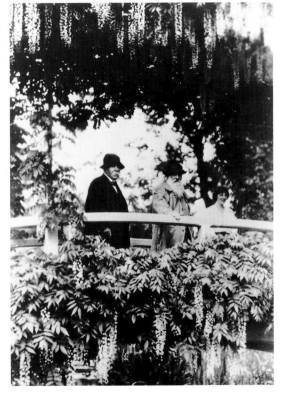

and wished for Monet to be accorded the most brilliant recognition .

The formal document was signed on 12 April 1922 after many comings and goings. It stated that Monet was giving France nineteen panels with would be exhibited at the Orangerie in the Tuileries gardens, arranged to accommodate them, but only after the painter's death.

∧
*Nymphéas
(Water lilies)*
c. 1917

Oil on canvas
100 × 300 cm
Michel Monet Bequest, 1966
Inv. 5118

<
*Georges Clemenceau
and Claude Monet
on the Japanese bridge*

Photograph
Michel Monet Bequest, 1966

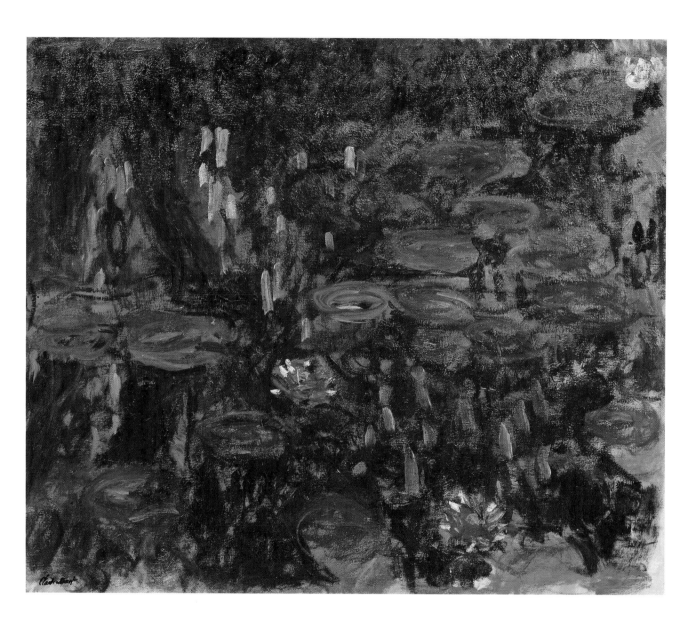

∧
Nymphéas. Reflets de saule
(Water lilies. Willow tree reflections)
c. 1916

Oil on canvas
131 × 155 cm
Michel Monet Bequest, 1966
Inv. 5099

>
Nymphéas. Reflets de saule
(Water lilies. Willow tree reflections)
c. 1916

Oil on canvas
200 × 200 cm
Michel Monet Bequest, 1966
Inv. 5122

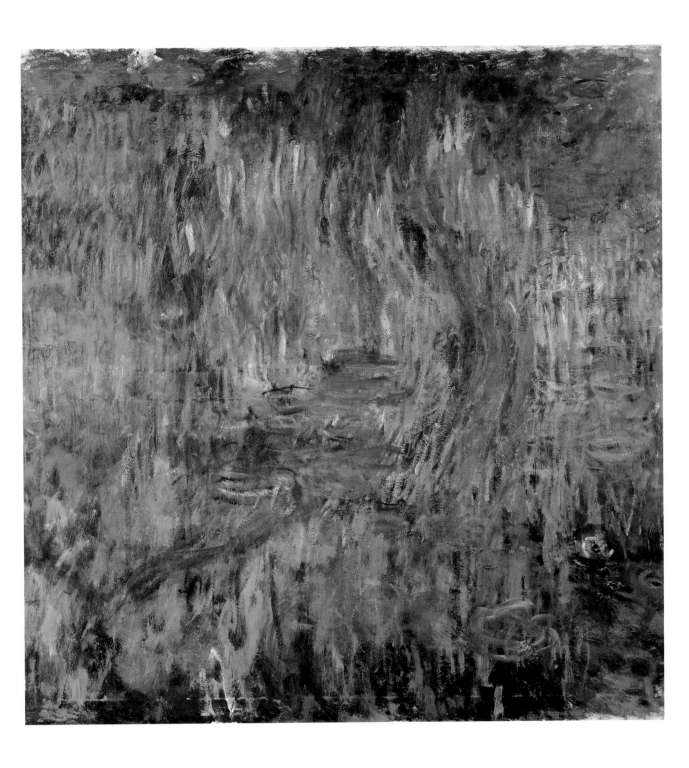

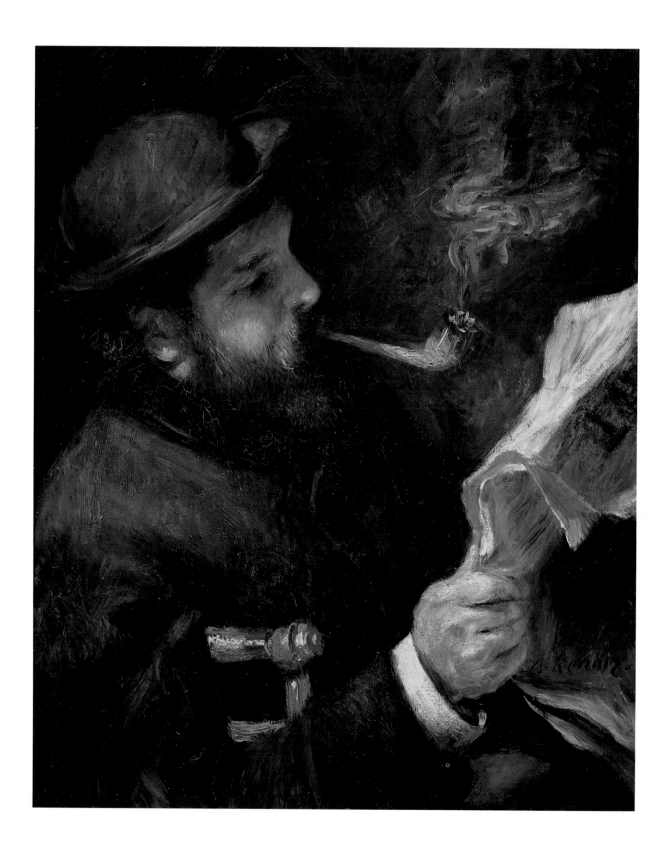

An admirable collection

"I love all beautiful things," Monet used to say to explain why the works of his fellow artists hung beside his own at his house. There were many artists who shared their homes only with their own creative output, whereas Monet enjoyed living as an aesthete in his world in which everything that in his eyes deserved to be there was on show.

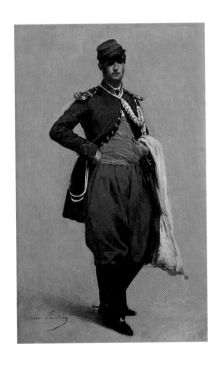

<
Auguste Renoir
(1841-1919)
*Claude Monet lisant
(Claude Monet, reading)*
1872
Oil on canvas
61 × 50 cm
Michel Monet Bequest, 1966
Inv. 5013a

∧
Charles Marie Lhuillier
(1824-1898)
*Portrait de Claude Monet
en uniforme
(Portrait of Claude Monet
in uniform)*
1861
Oil on canvas
37 × 24 cm
Michel Monet Bequest, 1966
Inv. 5041

Acquisitions, gifts, exchanges, undying or more anecdotal memories with the Japanese prints, the works hanging on the walls at Giverny formed admirable collection. Several astounded visitors described it and the inventory drawn up by Durand-Ruel on Monet's death gives a precise account of it. Many of these works remained together thanks to Blanche Hoschedé who preserved them, and Michel Monet who wanted to bequeath the whole of what was so dear to his father for posterity.

In a rare memento of his time as a volunteer which soon came to nothing, Monet poses proudly as a *Chasseur d'Afrique* (soldier in the African light cavalry regiment). Charles Marie Lhuillier, like Monet a former pupil of Ochard in Le Havre, shows his comrade on his return from Algeria in uniform, a blue tunic, red trousers, shoulder braid and a kepi. If this was a token of admiration, there is nothing to suggest it was mutual. Lhuillier's name is mentioned only once in Monet's correspondence. In that letter written to Eugène Boudin in May 1859, he recounts his visit to the Salon. A few painters are praised to the skies, others disparaged, like poor Lhuillier whose picture "commits a lot of sins!".

Another portrait of Monet was painted four years later by a friend of Bazille's in whose house Monet had lodgings. Gilbert Séverac, a painter from Toulouse, portrays his model almost beardless, his hair smoothed back, sitting legs astride, staring at the viewer with the determined

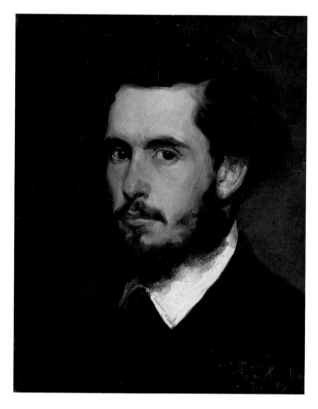

> ∧
Gustave Caillebotte
(1848-1894)
Chrysanthèmes blancs et jaunes.
Jardin du Petit Gennevilliers
(White and yellow chrysanthemums.
Garden at Petit Gennevilliers)
1893

Oil on canvas
73 × 60 cm
Michel Monet Bequest, 1966
Inv. 5061

∧
Charles Duran known
as Carolus-Duran
(1837-1917)
Portrait de Claude Monet
(Portrait of Claude Monet)
1867

Oil on canvas
46 × 38 cm
Michel Monet Bequest, 1966
Inv. 5114

>
Édouard Manet
(1832-1883)
Tête d'Homme (Claude Monet)
(Man's head {Claude Monet})
1874

Indian ink wash
17 × 14 cm
Michel Monet Bequest, 1966
Inv. 5036

look of a young man full of ardour. It was at this period that he was working on his *Déjeuner sur l'herbe* (The Picnic), an ambitious project for the young painter which Boudin described as a "huge piece of nonsense that is costing him an arm and a leg".[1] This portrait oncehung among other works on the wall of Bazille's studio and is featured in his famous *Atelier de la rue de Furstemberg* (Studio on rue de Furstemberg) painted in 1865 (Montpellier, Musée Fabre).

His exaltation was short-lived. Harsh periods sometimes knocked the artist off course. In 1867, doubt and apprehension were the consequences of the very real financial difficulties he was facing. Added to them was the imminent birth of the first child being carried by young Camille Doncieux, a child his family in Le Havre were determined to know nothing of. It was then that Carolus-Duran, a successful portraitist, painted the severe image of Claude Monet, with short hair and a black beard following the line of his jaw.

Other likenesses of Monet were made by closer friends. They are imbued with esteem and affection.

When Renoir came to see his friend at Argenteuil where Monet had taken up residence with his family in 1872, they set up their easels side by side. The two artists had already known one another for ten years, and this closeness was to last as long as they lived. "The Impressionist portrait painter" took advantage of these moments in the country to paint Monet and his wife several times, but always separately. One example is the intimist depiction he made of him, wearing a round hat, sitting down, leaning on the elbow-rest of a chair, smoking his pipe and reading his newspaper. The dark colours used contrast with the luminosity of the face lit up with orange and pink. Renoir also made a study of the delicate face of Camille, as a pendant to the *Portrait de Claude Monet lisant* (Portrait of Claude Monet, reading). Throughout his life, Monet would keep the two works, happy reminders of life on the banks of the Seine. When Auguste Renoir died in 1919, he confided his deep sadness to Geffroy: "The death of Renoir is a sore blow to me. With him a part of my life disappears, the struggles and enthusiasms of youth. It is very hard. And here I am the survivor of that group."[2]

Édouard Manet also came to spend a few days at Argenteuil as a friend, as a neighbour when he was staying at Gennevilliers on the opposite bank of the Seine, and sometimes as a colleague when it was a question of coming to carry out a study at Monet's house, where the protagonists in the scene were none other than his hosts. The profile with Monet's incisive features in Indian ink was made c. 1874 when Manet was working on his picture of *Monet peignant dans son atelier* (Monet painting in his studio) (Bayerische Staatsgemäldesammlungen, Munich). The drawing was given to the model by its author and always remained in his collection.

Édouard Manet died in 1883, at the very time when Monet was moving in to Giverny. Out of respect for the man they all regarded as the leader of the Batignolles school, Monet devoted the time and energy required to defend

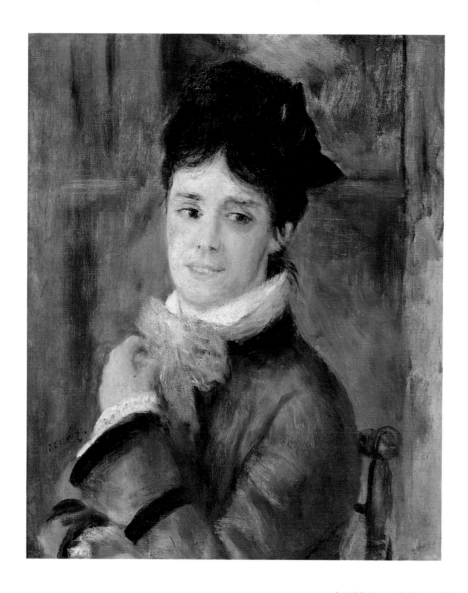

∧

Auguste Renoir
(1841-1919)
Portrait de Madame Claude Monet
(Portrait of Madame Claude Monet)
1872

Oil on canvas
61 × 50 cm
Michel Monet Bequest, 1966
Inv. 5013b

>

Auguste Renoir
(1841-1919)
Jeune fille assise au chapeau blanc
(Young girl in a white hat, seated)
1884

Pastel
62 × 47 cm
Nelly Sergeant-Duhem Donation, 1985
Inv. 5330

his life's work. It was Monet who organized the subscription to buy *L'Olympia,* the "sullied virgin", "the Impure woman *par excellence*",[3] from his widow. He had to find the sum of twenty thousand francs to prevent it from being taken abroad, and thought it was the finest tribute that could be paid to the great man. "Yes, I truly believe that with his great talent and all he has done for modern art, Manet is entitled to have his place in the collections belonging to the State."[4] And for over a year he obstinately fought to raise the funds, then to get the donation accepted by the State. *L'Olympia* would remain at the Luxembourg for seventeen years before finally moving to the Louvre, thanks to the intervention of Clemenceau. This was not the only battle to silence the traditionalists and obtain the consent of the administration. On the death of Gustave Caillebotte in February 1894, Renoir

too had to confront the same lack of understanding, the same intransigence. This time it was a matter not only of honouring the donor but also of the official recognition of the movement. The bequest of the Caillebotte collection to the State provoked many ripples. According to the terms of the document which dates from as early as 1876, sixty Impressionist works by Monet, Degas, Cézanne, Renoir and Pissarro (but unfortunately not a single one by Caillebotte) were to be exhibited permanently at the Musée du Luxembourg until the Louvre took them in.

The opposition was harsh and virulent, and it was three years before the will's executors, Renoir and Martial Caillebotte, had the pleasure of attending the official opening. Finally forty Impressionist pictures went to the Luxembourg in strength.

∧
Gustave Caillebotte
(1848-1894)
La Leçon de piano
(The piano lesson)
1881

Oil on canvas
81 × 65 cm
Michel Monet Bequest, 1966
Inv. 5028

>
Gustave Caillebotte
(1848-1894)
Rue de Paris, temps de pluie
(Paris street in the rain)
1877

Oil on canvas
54 × 65 cm
Michel Monet Bequest, 1966
Inv. 5062

Gustave Caillebotte met Monet in 1876 when he took part in the second exhibition of the Impressionist group. From a wealthy family, he gave his friends both financial and moral support, which they often needed. At a very early stage, he commissioned works from them, as Monet states in his account book: "sell M. Caillebotte painter several canvases". Then their shared enthusiasm for gardening was a further bond: "Don't fail to come on Monday as agreed, all my irises will be in flower; later some would have passed."[5] Fervour in this field was not the preserve of painters - Octave Mirbeau, the novelist, shared their passion: "I'm very pleased you're bringing Caillebotte," Monet wrote to Mirbeau, "we'll talk gardening, as you say, for art and literature are bunkum. There is only the soil."[6]

Rue de Paris, temps de pluie (Paris street in the rain), *La Leçon de piano* (The piano lesson) and *Chrysanthèmes blancs et jaunes. Jardin du Petit Gennevilliers* (White and yellow chrysanthemums. Garden at Petit Gennevilliers) were given to Claude Monet by their author as a token of friendship. Over and above any dissensions, every single one of the Impressionists demonstrated adherence and loyalty to the group. Monet too was devoted to those he liked, and never less than totally generous. Renoir declared, "but for him, I would have given up".

>
Camille Pissarro
(1830-1903)
Les Boulevards extérieurs. Effets de neige
(The outer boulevards. Snow effects)
1897

Oil on canvas
54 × 65 cm
Victorine Donop de Monchy Bequest, 1957
Inv. 4021

∨
Camille Pissarro
(1830-1903)
L'hiver. Retour de la foire
(Winter. Return of the fair)
1878

Gouache
14 × 54 cm
Roger Hauser Bequest, 1990
Inv. 5233

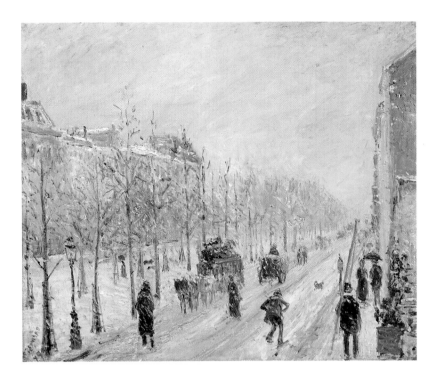

Once his reputation was established, he did not forget his fellow artists from the Batignolles district or the Gleyre studio, any more than he did their joint fight against the fixed ideals of the contemptuous public and the hostile critics. While in his early days he often requested the help of rich art-lovers, he in his turn gave his support to some of his friends in their struggle against poverty. By 1887 Monet was tasting success, and gradually saw money worries become a thing of the past. "In fact the movement in our favour is becoming more marked this year,"[7] he noted, and a little later: "In Paris things are going as well as they could for me, even beyond my hopes."[8] Immediately, to alleviate the period of destitution Pissarro was experiencing, Monet was happy to be able to advance him some sums of money or buy pictures from him.

In spite of long periods of separation, the sincere understanding between the two men endured. Pissarro was the eldest of the group, "a kind of patriarch of Impressionism".[9] The earlier celebrity of Monet, the artistic development of each artist, and the Neo-Impressionist experiments by the master from Eragny never adversely affected this special bond. "There have been a few slight clashes or differences of

opinion regarding groupings or schools," Monet; admitted, "a stupid thing, really, we're too old friends."[10] Monet and Rodin, both born in Paris in November 1840 two days apart, only frequented one another in the 1880s, but right away showed reciprocal esteem for one another. "The same feeling of fraternity, the same love of art, has made us friends for always,"[11] Rodin declared to him. Gradually the idea of bringing together the sculpture of Rodin, who already had an established public reputation, and the painting of Claude Monet at the Galerie Georges Petit took shape. "Me as the only painter and Rodin as the sculptor"[12]: a two-man exhibition which gave the artist the hope of sharing in Rodin's good fortune, but inspired him with the fear of not being ready in time. "Oh, I really curse it, this exhibition, and what worries I have created for myself with it, but also what need, what ambition, what vanity!"[13] Monet worked frenetically, and tried to bring together the major pictures in his work for the occasion, calling on buyers and dealers.

"I am approaching you to request a great service," he wrote to the gallery owner Charpentier. "Rodin and I are going to open a very major exhibition in rue de Sèze at Petit's. Where I am concerned, some of the best work I have done over the past 20 years. I would be very happy if you would lend me your *Glaçons* (Melting ice)."[14] He collected together 145 pictures, a virtual retrospective, while Rodin exhibited thirty-six sculptures. The press coverage was good. In his article of 25 June 1889 Mirbeau celebrated their talent: "It is they who in this century most gloriously, most definitively embody these two arts: painting and sculpture." Without being certain of the dates, we know that Rodin, who received a canvas by Monet as a gift, presented the painter with two of his works: a plaster, *Jupiter taureau, le faune et la femme* (Jupiter as a bull, the faun and the woman), and a bronze, *Jeune femme à la grotte* (Young woman in the cave), for which Monet thanked him warmly in May 1888: "Let me tell you how delighted I am with the fine bronze you sent me. I have put it in my studio so that I can see it constantly."[15]

Where Berthe Morisot was concerned, Monet gave her the decoration she so much wanted, and reinterpreted

ˇ
Auguste Rodin
(1840-1917)
Le Frère et la sœur
(The brother and sister)
c. 1890
Bronze
40 cm
Nelly Sergeant-Duhem Donation, 1985
Inv. 5318

>
Auguste Rodin
(1840-1917)
Jupiter taureau, le faune
et la femme
(Jupiter as a bull, the faun
and the woman)
c. 1886
Plaster
34 cm
Michel Monet Bequest, 1966
Inv. 5127

> ˇ
Auguste Rodin
(1840-1917)
Jeune femme à la grotte
(Young woman in the cave)
1885
Bronze
38 cm
Michel Monet Bequest, 1966
Inv. 5180

Bordighera to comply with her choice. How would it have been possible to withstand the charm of the young woman who had had the courage to join forces with the "refusés" (those rejected by the Salon), stay alongside the intransigents, and continue to keep company with the "aliénés" (lunatics) throughout their long journey? He had regard for Édouard Manet's sister-in-law who organized the famous Thursday dinners to which literary figures, painters and musicians were invited. He esteemed her as an artist and never tired of having his works hang alongside hers. "I've shown my mettle, and proved to you that my keenest wish was to exhibit with you."[16]

Monet was very upset when he learnt of Berthe Morisot's death in 1895 while staying in Norway with his stepson, Jacques Hoschedé, and wrote to his wife: "I am regretting not having seen her for a last time before I left, and it is a great sorrow to think that she is no longer there, she was so intelligent, had so much talent, I can't stop thinking about it."[17] To pay a last tribute to her, along with Degas, Mallarmé and Renoir he orga-nized a very complete exhibition of her work. Monet lent the delightful pastel *Fillette au panier* (Little girl with a basket) to that retrospective, which was held

>
Berthe Morisot
(1841-1895)
Julie Manet et sa levrette Laërte
(Julie Manet and her greyhound Laërte)
1893

Oil on canvas
73 × 80 cm
Michel Monet Bequest, 1966
Inv. 5027

V
Berthe Morisot
(1841-1895)
Fillette au panier
(Little girl with a basket)
1891

Pastel
58 × 41 cm
Michel Monet Bequest, 1966
Inv. 5039

>
Berthe Morisot
(1841-1895)
Au bal
(At the ball)
1875

Oil on canvas
62 × 52 cm
Victorine Donop de Monchy Bequest, 1957
Inv. 4020

>
Alfred Sisley
(1839-1899)
Printemps aux environs de Paris. Pommiers en fleurs
(Spring in the vicinity of Paris. Apple-trees in blossom)
1879

Oil on canvas
45 × 61 cm
Victorine Donop de Monchy Bequest, 1957
Inv. 4025

in May 1896 at the Galerie Durand-Ruel. In fulfilment of her deceased mother's wish, Julie Manet offered Claude Monet a picture. He chose *Julie Manet et sa levrette Laërt*e (Julie Manet and her greyhound Laërte); in Durand-Ruel's Monet inventory it would be listed as hanging on the wall of the artist's bedroom.

Beside it in that same room there was also a work by Alfred Sisley. As a young pupil at the Gleyre studio in 1862, Sisley attached himself to the three friends, Bazille, Renoir and Monet, and took part with them in the expeditions to the Auberge du Cheval-Blanc at Chailly, or the Ferme Saint-Siméon, with the lack of constraint of a young artist who admittedly had lots of talent, but was still dependent on his family. Unfortunately the family experienced the horrors of financial ruin in 1870, and then it was Sisley who had to attend to their needs. The fame of the great landscape painter only came posthumously. When he died in 1899, Monet, organized a sale for the benefit of his children in order to help them. He launched the idea of adding to the works left by Sisley any paintings his friends might wish to give. As the culmination of a real letter-writing campaign, collectors and dealers fought over the canvases of Alfred Sisley which achieved incredible prices, never seen in his lifetime.

For his part Monet, who had still been selling a painting for a few hundred francs in 1884, was now parting with

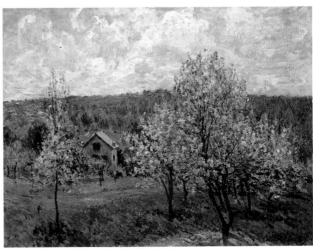

Un temps gris de Vernon (Grey weather at Vernon) for six thousand francs, while a *Bassin aux Nymphéas* (Water lily pond) could fetch ten thousand. Along with fame came a welcome prosperity allowing Monet to live more serenely and devote himself fully to his experiments. At Giverny he worked unremittingly, and increased the number of pictures. Many of them lined the walls of his house. On his death in 1926 they would remain at Giverny. His son Michel would inherit them. He later bequeathed them along with his father's personal collection and the house with its fabulous garden.

Parallel histories

Outside Impressionism, other artists pursued their careers. While the painting of some diverged from that movement totally, the approach of others was more comparable and several contemporaries crossed the path of the master of Giverny.

Albert Lebourg, nine years his junior, also spent his childhood in Normandy. After studying drawing at Rouen, he obtained a first post as a teacher at the École des Beaux-Arts in Alger. Once back in Paris, thanks to the dealer Portier he participated in the fourth Impressionist exhibition in 1879 alongside Monet. Recognition would not come until many years later. The story of his visit to the Monet exhibition at Durand-Ruel's in 1914 attests to the admiration he felt for his elder: "in these rooms with their so discreet backgrounds, (…) what delight!"[1] The esteem was mutual if we can rely on the letter Monet addressed to Gustave Geffroy when Lebourg exhibited 116 paintings at the Galerie Georges Petit: "You can imagine how happy I would be to see you and visit the Lebourg exhibition – I have a great liking for him too."[2]

Another person to feature in the Impressionist exhibitions, Jean-François Raffaëlli, was introduced into their circle in 1877 by the art critic Duranty, who introduced Raffaëlli to Degas at the Brasserie de la Nouvelle Athènes. Caillebotte rejected Raffaëlli as a candidate for the fourth Impressionist exhibition, but in 1880 Degas succeeded in getting him accepted by the group of "reprouvés" (reprobates), and consequently he exhibited alongside Félix and Marie Bracquemond, Caillebotte, Mary Cassatt, Forain, Gauguin, Guillaumin, Lebourg, Berthe Morisot and Pissarro. Raffaëlli submitted over thirty works, the largest contribution. They

<
Henri Le Sidaner
(1862-1939)
Clair matin à Quimperlé
(Bright morning at Quimperlé)

Oil on canvas
73 × 92 cm
Nelly Sergeant-Duhem Donation, 1985
Inv. 5275

were mainly pictures of Asnières, landscapes and figures of rag-pickers.

He repeated the experience the following year, even though his work differed from that of the other participants, as Arsène Alexandre pointed out: "In 1880 and 1881 he had exhibited with the Impressionists, more through an affinity in being independent than through any analogy of procedures or concept, for nothing in Raffaëlli's art is pure impression, but impression mixed with reflection."[3] Conscious of his dissimilarities, Raffaëlli was above all a historian of the Paris suburbs and an observer of their inhabitants. Associating his vision to that of Edmond de Goncourt, Alphonse Daudet and Gustave Geffroy, his work was the expression in the plastic arts of the primarily literary naturalist tendency. At the opposite pole from the plein-air painters and often related to the Symbolists, Eugène Carrière – "impossible to categorise" – enjoyed great fame in his own day. He virtually excluded colour from his palette, confining himself to brown monochromes. His favourite themes were interiors, family scenes and mother and child. In Rodin's view, "All he had to do to be sublime was celebrate maternal love"; Rodin was very fond of Carrière, an affection increased by similar aesthetic ideals and objectives. The critics of the period were not mistaken in saying, "They turn painting and statuary into psychologically expressive arts."[4]

Of the following generation, Henri Le Sidaner, a pupil of Cabanel, "was therefore like many others freed from the academic ascendancy by Monet's Impressionism. As early as 1894 he was induced (...) to adopt the technique of divided colours, as created by Monet"[5]. While the procedure is Impressionist, his silent, intimist landscapes, his townscapes and his laid tables express a moderate Symbolism. In 1901 he lived at Gerberoy in the Oise and made his garden an inexhaustible source of subject matter, as Monet did Giverny.

Some artists like Paul Signac openly acknowledged Monet's influence. Signac was eighteen when he discovered his works; "What prompted me to take up painting? It was Monet, or rather seeing some reproductions of his pictures in *La Vie Moderne*." The pictures he painted at this period reveal the influence of the Giverny

∧
Eugène Carrière
(1849-1906)
La Coiffure
(The Hair-do)

Oil on canvas
38 × 46 cm
Nelly Sergeant-Duhem Donation,
1985
Inv. 5297

> ∧
Albert Lebourg
(1849-1928)
Le Quai de la Tournelle
et Notre-Dame de Paris
(The Quai de la Tournelle
and Notre-Dame de Paris)
1909

Oil on canvas
53 x 81 cm
Nelly Sergeant-Duhem Donation,
1985
Inv. 5273

>
Paul Signac
(1863-1935)
Venise
(Venice)
1908

Watercolour
19 × 25 cm
Michel Monet Bequest, 1966
Inv. 5074

master, and soon he requested a meeting: "I've been doing painting for ten years, never having had any models other than your works and following the great path you have opened up for us.(..) I would be so happy to be able to show you five or six of my studies on the basis of which you could form an opinion of me and give me some of the advice I so much need."[6] Monet gladly granted him an interview, even though he had never wanted to explain his art and always rejected over-subtle commentaries.

At the final Impressionist exhibition in 1886, Signac was generously represented alongside Degas, Seurat and Pissarro. But Monet, Renoir and Sisley were absent. Degas was forced to change its title, and the show was simply called "Huitième exposition de peinture" (Eighth exhibition of painting).

It was the end of the century and the end of a period. Impressionism, though disputed by some, was no longer an avant-garde movement.

At the beginning of the 20th century, Monet settled down to do his *Paysages d'eau* (Water landscapes). He was at last experiencing very great fame. Posterity shows that his talent was useful to many painters, and perhaps guided a few musicians towards new sound images.

The power of his palette, the fluidity of his images and the orgy of brushstrokes, the innovativeness of his series, the huge formats, the disintegration of the motif and the invented lyrical abstraction have made of Claude Monet one of painting's geniuses.

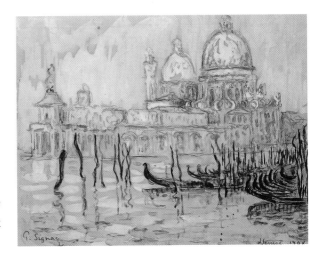

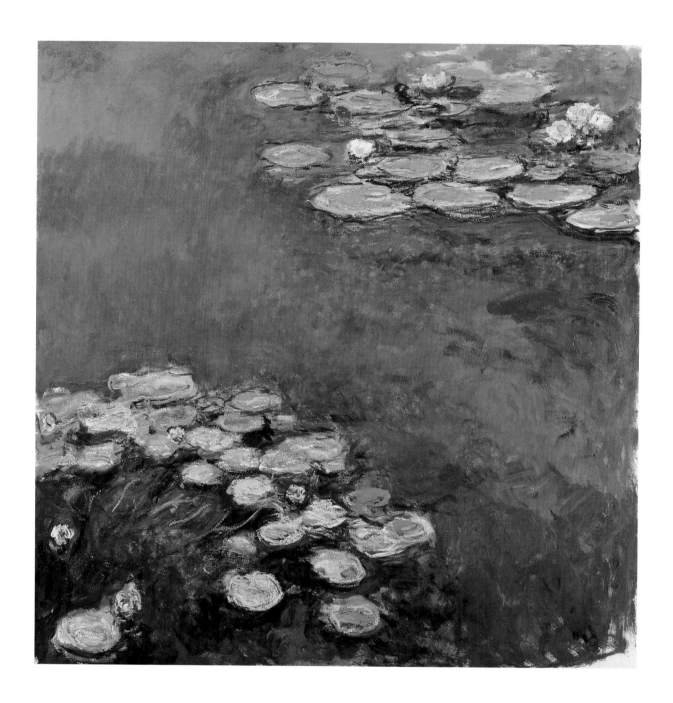

∧
Nymphéas
(Water lilies)
c. 1914

Oil on canvas
200 × 200 cm
Michel Monet Bequest, 1966
Inv. 5115

Notes

How the museum came into being

1 Claude Roger-Marx, *Le Figaro*, 7 June 1971.

The arrogance of youth

1 Thiébault-Sisson, "Claude Monet, les années d'épreuves", *Le Temps*, 26 November 1900.

2 Ibid.

3 Ibid.

4 John Rewald, *History of Impressionism,* New York, 4th rev. ed., 1973.

5 Wildenstein, *Claude Monet. Biographie et catalogue raisonné*, Lausanne, 1974, I, p. 5.

6 Marc Elder, *À Giverny chez Claude Monet*, Paris, 1924, p. 16.

7 Letter from Monet to Boudin, Paris, 3 June 1859, Wildenstein, I, 2.

8 Letter from Monet to Boudin, Paris, 19 May 1859, Wildenstein, I, 1.

9 Georges Clemenceau, *Claude Monet*, Paris, Perrin, 2000, p. 14.

10 Marthe de Fels, *La Vie de Claude Monet*, Paris, 1929.

11 Letter from Monet to Gustave Geffroy, Giverny, 8 May 1920, Wildenstein, IV, 2348.

12 Letter from Monet to Bazille, Honfleur, 26 August 1864, Wildenstein, I, 9.

13 Letter from Boudin to Monet, Deauville, 28 July 1892.

14 *Catalogue de tableaux, esquisses, études, aquarelles par feu J. B. Jongkind*, Paris, Drouot, 7 and 8 December 1891, p. 17.

15 Philippe Burty, *La République française*, 25 April 1874.

16 Letter from Manet to Émile Zola, 2 January 1867, Rouart and Wildenstein, I, p. 14.

17 Ibid.

18 Ibid.

19 Letter from Bazille to his mother, April 1867.

20 Marion, 1866, a friend of Cézanne.

21 Maurice Guillemot, *Claude Monet, La Revue illustrée*, 15 March 1898.

Figures and silhouettes

1 Clemenceau, *Claude Monet*, Paris, Perrin, 2000, p. 23.

2 Letter from Monet to Alice Hoschedé, Le Palais, 14 September 1886, Wildenstein, II, 686.

3 Letter from Monet to Alice Hoschedé, Kervilahouen, 17 November 1886, Wildenstein, II, 750.

4 Georges Clemenceau, *Claude Monet*, Paris, Perrin, 2000, p. 29.

Beside water

1 Gustave Geffroy, *Claude Monet, sa vie, son oeuvre*, 1980, Paris, Macula, p.8.

2 Théodore Duret, *Les peintres impressionnistes*, Claude Monet, Paris, 1878, p. 19.

3 Thiébault-Sisson, "Autour de Claude Monet, anecdotes et souvenirs. II", *Le Temps*, 8 January 1927

4 Letter from Monet to Murer, Vétheuil, 1 September 1878, Wildenstein, I, 136.

5 Georges Clemenceau, *Claude Monet*, Paris, Perrin, 2000, p. 81.

6 Letter from Monet to M. Joyant, Giverny, 8 February 1896, Wildenstein, III, 1322.

7 Letter from Monet to Alice Hoschedé, Pourville, 15 February 1882, Wildenstein, II, 242.

8 Letter from Monet to Alice Hoschedé, Étretat, 1 February 1883, Wildenstein, II, 312.

9 Letter from Monet to Alice Hoschedé, Étretat, 1 November 1885, Wildenstein, II, 605.

10 Guy de Maupassant, "La vie d'un paysagiste", *Gil Blas*, 28 September 1886.

11 Letter from Monet to P. Desachy, Giverny, 26 August 1916, Wildenstein, IV, 2191.

12 Letter from Monet to J. Durand-Ruel, Giverny, 29 October 1917, Wildenstein, IV, 2247.

13 Letter from Monet to G. Bernheim-Jeune, Giverny, 1 November 1917, Wildenstein, IV, 2248.

Snow effects

1 Octave Mirbeau, "Claude Monet", *La France*, 21 November 1884.

2 Letter from de Bellio to Monet, Paris, 1 November 1876, Wildenstein, I, 29.

3 *Journal de Bordeaux*, 11 April 1883.

Townscape painter

1 Émile Zola, *L'Œuvre*, 1886.

2 Émile Zola, "Une exposition : les peintres impressionnistes", 1877.

3 Letters from Monet to Alice Hoschedé, Rouen, 18 March, 3 April, 7 April 1893, Wildenstein, III, 1140, 1146,1209.

4 Georges Clemenceau, *La Justice,* 20 May 1895.

Travel

1 Letter from Renoir to Durand-Ruel, December 1883.

2 Thiébault-Sisson, "Claude Monet, les années d'épreuve", *Le Temps*, 26 November 1900.

3 Ibid.

4 Ibid.

5 Letter from Monet to Duret, Giverny, 1887, Wildenstein, III, 797.

6 *Exposition Claude Monet. Vues de la Tamise à Londres*, Paris, Galerie Durand-Ruel, 9 May to 4 June 1904, Preface, p. 5.

7 Arsène Alexandre, "La Tamise par Claude Monet", *Le Figaro*, 8 May 1904.

8 Letter from Monet to Pissarro, Zaandam, 17 June 1871, Wildenstein, I, 59.

9 Letter from Monet to Théodore Duret, The Hague, French Legation to the Netherlands, 30 April 1886, Wildenstein, II, 671.

10 Letter from Monet to Théodore Duret, Bordighera, 2 February 1884, Wildenstein, II, 403.

11 Letter from Monet to Alice Hoschedé, Bordighera, 18 February 1884, Wildenstein, II, 422.

12 Letter from Monet to Alice Hoschedé, Bordighera, 10 March 1884, Wildenstein II, 441.

13 Maurice Rollinat (1846-1903).

14 Letter from Monet to Berthe Morisot, Fresselines, Creuse, 1889, Wildenstein, III, 943.

15 Letter from Monet to Gustave Geffroy, Fresselines, 24 April 1889, Wildenstein, III, 963.

16 Letter from Monet to Blanche Hoschedé, Sandviken, 1 March 1895, Wildenstein, III, 1276.

At Giverny

1 Envelope of a letter from Mallarmé to Monet, 18 June 1888.

2 Letter from Monet to Alice Hoschedé, Pourville, 19 March 1882, Wildenstein, II, 257.

3 Letter from Monet to Duret, Giverny, 20 May 1883, Wildenstein, II, 354.

4 Letter from Monet to Paul Durand-Ruel, Giverny, 5 June 1883, Wildenstein, II, 356.

5 Letter from Monet to Paul Durand-Ruel, Giverny, 27 October 1890, Wildenstein, III, 1079.

6 Letter from Monet to Paul Durand-Ruel, Giverny, 5 June 1883, Wildenstein, II, 356.

7 Marcel Pays, *L'Excelsior,* 1920.

8 Arsène Alexandre, *Claude Monet*, 1921, p. 107.

9 Octave Mirbeau, "Claude Monet", *L'Art dans les Deux Mondes*, 7 March 1891.

10 Ibid.

11 Letter from Monet to Gustave Geffroy, Giverny, 19 May 1911, Wildenstein, IV, 1966.

12 Letter from Monet to Madame Jean-Pierre Hoschedé, Giverny, 14 September 1914, Wildenstein, V, 3102.

13 Letter from Monet to Bernheim-Jeune, Giverny, 5 August 1912, Wildenstein, IV, 2024a.

14 Letter from Monet to Clemenceau, Giverny, 13 September 1923, Wildenstein, IV, 2533.

15 Letter from Monet to Dr. Mawas, Giverny, 25 March 1925, Wildenstein, IV, 2596.

16 Arsène Alexandre, *Claude Monet*, 1921, p. 107.

17 Wildenstein, vol. III, no. 1392, *Bassin aux nymphéas, hiver* (Water-lily pond, winter).

18 Arsène Alexandre, *Claude Monet*, 1921, p. 108

19 Émile Zola, "Les Actualistes", *L'Evénement Illustré*, 24 May 1868.

20 Letter from Monet to Gustave Geffroy, Giverny, 16 January 1918, Wildenstein, IV, 2644.

21 Gustave Geffroy, *Monet, sa vie, son oeuvre*, 1924, p.401.

22 Letter from Monet to Gustave Geffroy, 11 August 1908, Wildenstein, IV, 1854.

23 Octave Mirbeau, "Claude Monet", *La France*, 21 November 1884.

24 Letter from Monet to Clemenceau, 12 November 1918, Wildenstein, IV, 2287.

An admirable collection

1 Eugène Boudin to his brother, winter 1865-1866.

2 Letter from Monet to Gustave Geffroy, Giverny, 8 December 1919, Wildenstein, IV, 2328.

3 Paul Valéry, *Triomphe de Manet*, 1932.

4 Letter from Monet to Arsène Alexandre, Giverny, 27 January 1890, Wildenstein, V, 2774.

5 Letter from Monet to Gustave Caillebotte, Giverny 1891, Wildenstein, III, 1430.

6 Letter from Octave Mirbeau to Monet, 27 September 1890.

7 Letter from Monet to Paul Durand-Ruel, Giverny, 13 May 1887, Wildenstein, III, 788.

8 Letter from Monet to Duret, Giverny, 1887, Wildenstein, III, 799.

9 Gustave Geffroy, *Préface au catalogue de la collection de Madame Veuve C. Pissarro*, Paris, 1921, p.1.

10 Letter from Monet to Pissarro, Giverny, 7 February 1891, Wildenstein, III, 1099.

11 Letter from Rodin to Monet, Montrozier, 22 September 1897.

12 Letter from Monet to Paul Durand-Ruel, Fresselines, 1 May 1889, Wildenstein, III, 969.

13 Letter from Monet to Alice Hoschedé, Fresselines, 1 May 1889, Wildenstein, III, 970.

14 Letter from Monet to Charpentier, Giverny, 27 May 1889, Wildenstein, III, 985.

15 Letter from Monet to Rodin, Giverny, May 1888, Wildenstein, III, 892.

16 Letter from Monet to Berthe Morisot, 25 May 1888, Musée Marmottan Monet.

17 Letter from Claude Monet to Alice Hoschedé, Sandviken, 10 March 1895, Wildenstein, III, 1281.

Parallel histories

1 Letter from Lebourg to Gustave Geffroy, Rouen, 12 March 1914, Wildenstein, IV, 265.

2 Letter from Monet to Gustave Geffroy, Giverny, 16 January 1918, Wildenstein, IV, 2644.

3 Arsène Alexandre, *Jean-François Raffaëlli, peintre, graveur, sculpteur*, Paris, 1909, p. 90.

4 Camille Mauclair, *La psychologie du mystère*, Paris 1901, p. 45.

5 Camille Mauclair, *Henri le Sidaner*, Paris, 1928, p. 56.

6 Letter from Paul Signac to Claude Monet, 1883.

Chronology

1840 Birth of Oscar Claude Monet in Paris on 14 November.

1845 His family moves to Le Havre.

1856 Produces his first caricatures and meets Eugène Boudin who introduces him to plein-air painting.

1857 Death of his mother.

1859 Leaves for Paris and enrols at the Académie Suisse where he meets Pissarro.

1861 Carries out his military service in Algeria.

1862 Return to Le Havre where he meets Jongkind. In Paris, enrols at the Charles Gleyre studio and makes friends with Bazille, Renoir, Sisley…

1863 Monet goes with Bazille to paint the landscapes of Chailly.

1864 Spends time in Normandy, in Rouen and Honfleur with Bazille, Boudin and Jongkind.

1865 The Salon jury accepts two landscapes by Monet. He starts work on *Déjeuner sur l'herbe* (The picnic), with Bazille posing for several figures in the painting.

1866 Chooses the young model Camille Doncieux to pose for *Femme à la robe verte* (Woman in the green dress), which is accepted for the Salon. Moves to Ville-d'Avray.

1867 Rejected by the Salon. Stays at Sainte- Adresse Birth of his son Jean - Bazille is the child's godfather.

1868 A seascape is accepted for the Salon. Leaves alone for Le Havre and is awarded the Jury's silver medal at the "Exposition maritime internationale". Monet experiences serious money worries.

1869 Lives at Bougival. Works with Renoir at "la Grenouillère".

1870 Marries Camille in Paris. Spends the summer at Trouville The Franco-Prussian War: Monet evades conscription, leaving for England where he is joined by Camille and Jean. Bazille dies on the battlefield. Through the good offices of Daubigny Monet meets Paul Durand-Ruel in London; the following year Durand-Ruel becomes his dealer.

1871 Returns to France via Holland. At the end of the year he rents a house at Argenteuil, which provides him with many motifs: a walk, the Seine, the railway bridge…

1873 Monet makes several sales including twenty nine paintings at the Durand-Ruel gallery. Travels to Étretat and Sainte-Adresse and this year paints *Impression, Soleil levant* (Impression, Sunrise) at Le Havre harbour.

1874 An exhibition is organized on the premises of the photographer Nadar in which Monet, Boudin, Bracquemond, Cézanne, Degas, Guillaumin, Morisot, Pissarro, Renoir and Sisley take part. *Impression, Soleil levant* provokes the irony of the critic Louis Leroy who entitles his article "L'exposition des Impressionnistes", so giving the movement its name. The famous picture is purchased by Ernest Hoschédé at the price of 800 francs.

1875 Monet takes part in the auction at the Hôtel Drouot organized by the independent artists, but makes only a paltry profit from it.

1876 2nd Impressionist Exhibition: Monet shows eighteen works at the Galerie Durand-Ruel. Ernest Hoschédé and his wife invite Monet to Montgeron to decorate their château.

1877 Monet paints several views of the Gare Saint-Lazare which he shows at the 3rd Impressionist Exhibition.

1878 Moves to Paris for a few months where his second son, Michel, is born. Then sets up home at Vétheuil with the Hoschedé family.

1879 Takes part in the 4th Impressionist Exhibition.
Camille, "almost always ill" since the birth of Michel, dies on 5 September.
During the harsh winter Monet draws inspiration mainly from the spectacle of the ice breaking up on the Seine.

1880 Exhibits an oil painting at the Salon: *Lavacourt*.
First solo exhibition devoted to Monet at the Galerie de la Vie moderne in Paris.
Gradually Claude Monet distances himself from the Impressionist group and gains his independence. From now on Durand-Ruel is very loyal in his support of the painter.
Alice does not go back to Paris with her husband, preferring to remain with the artist.

1881 They move to Poissy with their children.
Monet finally gives up the Salon.

1882 He takes part in the 7th Impressionist Exhibition.

1883 Durand-Ruel devotes a one-man show to fifty-six works by Monet.
Leaves this "horrible ill-fated Poissy" and with Alice discovers the village of Giverny.
Travels to the Riviera with Renoir.

1884 Claude Monet is enchanted by Bordighera "[…] that brilliance, that magical light […]" .

1886 At the 5th International Exhibition at the Georges Petit gallery shows two landsapes brought back from his recent trip to Holland.
Takes part in the "Exposition des XX" in Brussels.
Through the good offices of Durand-Ruel exhibits some forty paintings in New York.
Works at Belle-Île (*Portrait of Poly*) where he meets the art critic Gustave Geffroy.

1888 Goes to Antibes and Juan-les-Pins where he paints about thirty works.
Sells ten or so pictures to Théo Van Gogh for the Galerie Boussod-Valadon and goes back to London.

1889 The artist leaves for Fresselines, where he paints nine views of the valley at the confluence of the big and the little Creuse rivers where the only variant is the play of light: "[…]It's superb here, with a terrible wildness that reminds me of Belle-Île […]"
Monet exhibits with Rodin at the Galerie Georges Petit: "[…] me as the only painter and Rodin as the sculptor […]"
Organizes a subscription to buy *Olympia* by Manet and give it to the Louvre.

1890 Monet buys the property at Giverny, fits up a new studio.
Start of the series paintings: the haystacks, the poplars, the cathedrals in harmonies of white, blue and pink that reflect the variations of the light.

1892 Claude Monet marries Alice (Ernest Hoschedé died in 1891.)

1893 After buying a plot of land, Monet starts to create the water garden, with the water lily pond.

1895 Monet's "recent works" (twenty versions of Rouen cathedral) are shown at the Durand-Ruel gallery.
Then Monet spends the winter in Norway, bringing back "snow effects" (*Mont Kolsaas* (Mount Kolsaas), etc.)

1895 Return to the scenes of his youth: Pourville, Varengeville.

1896 Believed to be the year when the idea of the *Grandes décorations* (Giant decorations) were conceived. Monet works on the banks of his pond and already produces pictures in which the motif fills all the space, with no bank, sky or horizon visible (*Nymphéas. Effet du soir* - Water lilies. Evening effect).

1899 During three consecutive years, Monet travels to
London and paints the Houses of Parliament, Charing
Cross Bridge, the Thames.

1900 Exhibits several recent *Bassins aux Nymphéas*
(Water lily pond paintings) at the Durand-Ruel gallery.

1901 Purchases a new plot to extend his planting and
enlarge his pond.

1908 Goes off to Venice with Alice.

1909 Exhibition at the Durand-Ruel gallery: "Les Nymphéas,
Séries de paysages d'eau"; Forty eight paintings
from 1903 to 1908.

1911 On 19 May Alice Monet dies.

1914 Jean, the painter's elder son, dies prematurely.
His wife Blanche Hoschedé-Monet will in future live
with the artist.
Monet actually starts work on the grandes décorations.
He has a third studio built where they can be painted.

1915 Signature of the donation of eight water lily
compositions to be handed over to the Musée de
l'Orangerie after the artist's death.

1916 Monet has an operation for a cataract which has
been troubling him for several years.

1917 Durand-Ruel exhibits some *Nymphéas* (Water lilies)
paintings in New-York

1926 Monet dies on at Giverny 5 December.
On 17 May, official opening of the Grandes
Décorations des Nymphéas (Giant decorations of
Water lilies) at the Orangerie in the Tuileries gardens.

Selective bibliography

MONOGRAPHS

ALEXANDRE Arsène, *Jean-François Raffaëlli, peintre, graveur et sculpteur*, Paris, 1909

BATAILLE Marie-Louise and WILDENSTEIN Georges, *Berthe Morisot. Catalogue des Peintures, Pastels et Aquarelles*, Paris, Les Beaux-Arts, 1961

BENEDITE Léonce, *Albert Lebourg*, Paris, Galerie Georges Petit, 1923

BERHAUT Marie, *Gustave Caillebotte. Catalogue raisonné des peintures et pastels*, Paris, Bibliothèque des Arts, 1994.

CLEMENCEAU Georges, *Claude Monet*, Paris, Perrin, 2000

DAULTE François, *Alfred Sisley, Catalogue raisonné de l'œuvre peint*, Paris, Durand-Ruel, 1959

DAULTE François, *Auguste Renoir, Catalogue raisonné de l'œuvre peint. I Figures 1860-1890*, Lausanne, Durand-Ruel, 1971

DAULTE François, *Frédéric Bazille et les débuts de l'Impressionnisme*, Paris, Bibliothèque des Arts, 1992

DELAFOND Marianne and GENET-BONDEVILLE Caroline, *Berthe Morisot ou l'audace raisonnée*, Paris, Musée Marmottan, 1997

DISTEL Anne, *Signac au temps d'harmonie*, Paris, Gallimard, 2001

ELDER Marc, *À Giverny chez Claude Monet*, Paris, 1924

FELS Marthe de, *La vie de Claude Monet*, Paris, 1929

GEFFROY Gustave, *Claude Monet, sa vie, son œuvre*, Paris, Macula, 1980

HEFTING Victorine, *Jongkind, sa vie, son œuvre, son époque*, Paris, Arts et Métiers Graphiques, 1975

MAUCLAIR Camille, *Henri Le Sidaner*, Paris, Georges Petit, 1928

PISSARRO Ludovic Rodo and VENTURI Lionello, *Camille Pissarro, son art, son œuvre*, 2 vols., Paris, Paul Rosenberg, 1939

ROUART Denis and WILDENSTEIN Daniel, *Manet, Catalogue raisonné*, 2 vols., Lausanne and Paris, Bibliothèque des Arts, 1975

WILDENSTEIN Daniel, *Claude Monet. Catalogue raisonné*, 5 vols., Paris and Lausanne, Bibliothèque des Arts, 1974-1991

WILDENSTEIN Daniel, *Monet ou le triomphe de l'Impressionnisme*, 4 vols., Cologne, Taschen, 1999

VARIOUS WORKS

DURET Théodore, *Les peintres impressionnistes, Claude Monet*, Paris, 1878

MIRBEAU Octave, *Combats esthétiques 1*, Paris, Séguier, 1993

MONNERET Sophie, *L'Impressionnisme et son époque*, 4 vols., Paris, Denoël, 1978

REWALD John, *History of Impressionism*, New York, 4th rev. ed., 1973

ARTICLES

ALEXANDRE Arsène, "La Tamise par Claude Monet", *Le Figaro*, 8 May 1904

GUILLEMOT Maurice, "Claude Monet", *La Revue Illustrée*, 15 March 1898

MAUPASSANT Guy de, "La vie d'un paysagiste", *Gil Blas*, 28 September 1886

MIRBEAU Octave, "Claude Monet", *La France*, 21 November 1884

MIRBEAU Octave, "Claude Monet", *L'Art dans les Deux Mondes*, 7 March 1891

NICULESCU Remus, "Georges de Bellio. L'ami des impressionnistes", *Paragone*, nos. 247 and 249, Florence, 1970

THIEBAULT-SISSON, "Claude Monet, les années d'épreuves", *Le Temps*, 26 November 1900

THIEBAULT-SISSON, "Autour de Claude Monet, anecdotes et souvenirs II", *Le Temps*, 8 January 1927

ZOLA Émile, "Les Actualistes", *L'Événement Illustré*, 24 May 1868

SALE AND EXHIBITION CATALOGUES

Catalogue de tableaux, esquisses, études, aquarelles par feu J.B. Jongkind, Drouot, Paris, 7 and 8 December 1891

Catalogue de la collection de Madame Veuve C. Pissarro, Paris, 20 May to 20 June 1921

Claude Monet – Auguste Rodin. Centenaire de l'exposition de 1889, Musée Rodin, Paris, 1989

Eugène Carrière 1849-1906, Musées de Strasbourg, Strasbourg, 1996

Renoir's Portraits: Impressions of an Age, exhibition catalogue, National Gallery of Canada, Ottawa, 1997

Index

(Numbers in italics refer to illustrations.)

Photographic acknowledgements

All photographs come from the picture library of
the Bridgeman Giraudon agency, except the following:

© Musée Marmottan Monet archives:
pp 4, 6, 7 top, 7 bottom, 8 top, 17 bottom, 18 bottom,
28 bottom, 32, 34 top, 37, 40 bottom, 44, 46, 58, 59, 60,
70, 76 bottom.
© Bridgeman Giraudon Charmet : p 11

Photoengraving
Offset Publicité, La Varenne Saint-Hilaire

Printing
Mame Imprimeurs, Tours

Dépôt légal (Registration of copyright)
November 2002